50 GEMS OF

Wiltshire

ANDREW POWELL-THOMAS

AMBERLEY

For Karen Olver and family – forever grateful for the neighbourly help

First published 2022

Amberley Publishing
The Hill, Stroud
Gloucestershire, GL5 4EP

www.amberley-books.com

Copyright © Andrew Powell-Thomas, 2022

Map contains Ordnance Survey data © Crown copyright and database right [2022]

The right of Andrew Powell-Thomas to be identified as the Author
of this work has been asserted in accordance with the
Copyrights, Designs and Patents Act 1988.

British Library Cataloguing in Publication Data.
A catalogue record for this book is available from the British Library.

ISBN 978 1 4456 9892 2 (paperback)
ISBN 978 1 4456 9893 9 (ebook)

Typesetting by SJmagic DESIGN SERVICES, India.
Printed in Great Britain.

Contents

Cotswolds

Stroud
Chalford
Cirencester
Bampton

R Thames or Isis

Nailsworth
Lechlade on Thames

Dursley
Faringdon

Tetbury
Cricklade **26**

Highworth

Wantage

Malmesbury **23**

Royal Wootton Bassett

37

Yate

32

48 **10**

SWINDON

Lambourn

8

31

WEST

Lyneham
Chippenham

27

Corsham

Avebury

Marlborough

Batheaston

Calne

5

50 **2**

24

16 **20**

17

19

Hungerford

R Avon

18

North Wessex Downs

36

43

Melksham

12

45

15

7

Devizes

1

Bradford-on-Avon

6

13

Pewsey

Burbage

Trowbridge

Upavon

WILTSHIRE

42

Ludgershall

Westbury

22

Salisbury Plain

25

Andover

44

3

minster

38 Amesbury

21

40

Stockbridge

35

4

39 Mere

14 Wilton

47

28

Salisbury

Kings
Sombo

41

33/34

11 **9**

30

Romsey

29

Shaftesbury

Gillingham

49 **46**

Stalbridge

Sixpenny Handley

Fordingbridge

Totton

Verwood

Introduction

Landlocked Wiltshire, one of the largest counties in southern England, is often thought of as a rural backwater with little more than farmland and a few towns to shout about. But that couldn't be further from the truth. With high chalky downland and glorious wide valleys, grand castles and historic buildings, a range of natural beauty spots and interesting museums and fabulous festivals, Wiltshire has something to keep the whole family entertained. There are obviously far more gems in the county than the fifty in this book, and the biggest challenge for me was deciding which ones to include. As someone with a young family, we are constantly finding new places in the South West to visit and explore, and as such I have tried to include a range of gems that will appeal to everyone, young and old, active and relaxing. It is one thing to read about places and look at some pictures, but an entirely different thing to explore them yourself, and I would hope that if nothing else this book encourages you go and explore some of these wonderful sites.

1. Alton Barnes White Horse

The Alton Barnes White Horse, sometimes known as the Alton Priors White Horse, is a hill figure of a horse cut into the slope of Milk Hill, the tallest hill in Wiltshire. The chalk horse is over 50 metres tall and nearly 50 metres wide, and on a clear day it can be seen from over 20 miles away. Located to the north of Alton village, this

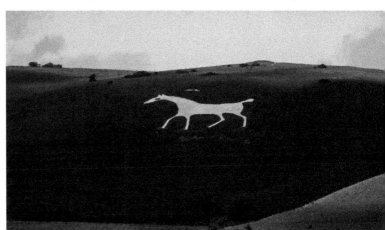

The Alton Barnes White Horse was most recently scoured in 2019 with 46 tonnes of pristine white chalk. (Courtesy of Amanda Slater CC BY-SA 2.0)

figure was cut into the hillside in 1812 on the instructions of local farmer Robert Pile and was excavated to a depth of half a metre and packed with chalk rubble. It is one of the country's most iconic white horses and has been regularly maintained throughout time through scouring. In 2009, to restore the fading horse, helicopters ferried in 150 tonnes of fresh chalk from south Wiltshire at a cost of £21,000. Helicopters were the only option as there is no vehicular access for lorries due to it being in a Site of Special Scientific Interest on a National Nature Reserve.

2. Avebury

This small village has an incredible history dating back thousands of years. The earliest evidence of settlement comes from a series of earthworks, believed to have been constructed sometime between 3400 and 2625 BC. It is also encircled by a Neolithic henge monument that consists of three stone circles – the largest of which is the biggest megalithic stone circle in the world. Many archaeologists agree that this site was used for some form of ritual or ceremony and was most likely linked to other nearby prehistoric structures. Although not a perfect circle, the henge has a circumference of over 1,000 metres and its outermost stone circle has huge stones up to 4 metres in height and weighing up to 40 tonnes. Towards the middle of the monument are the remains of two smaller circles of stones – the northernmost ring only has two stones still standing, while the southern ring was largely destroyed in the eighteenth century and its footprint is now covered by village buildings. Human

A stunning view of Avebury and its stone circle. (Courtesy of Detmar Owen CC BY-SA 4.0)

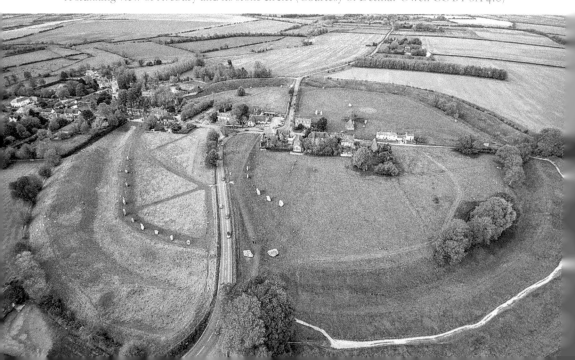

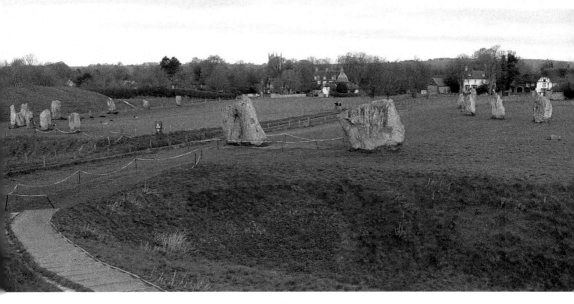

The stone circle of Avebury. (Author's collection)

bones found at the site suggest some sort of funerary purpose and the fact that the Avebury stone circle was a significant part of a wider ritual complex. In the late medieval period, when the country had converted to Christianity, the largest stone became know as 'Devil's Chair' and the three stones forming the central cove became known as 'Devil's Quiots' – all because this was a non-Christian monument. By the early fourteenth century villagers had started to pull down some of these stones, probably at the bequest of the local Christian priest, and a number were hauled to the ground, where they still lie today. This seems to have abruptly stopped around 1325, however, when a man was crushed to death by one of the toppling stones that

The sheer size of many of the stones is simply breathtaking. (Author's collection)

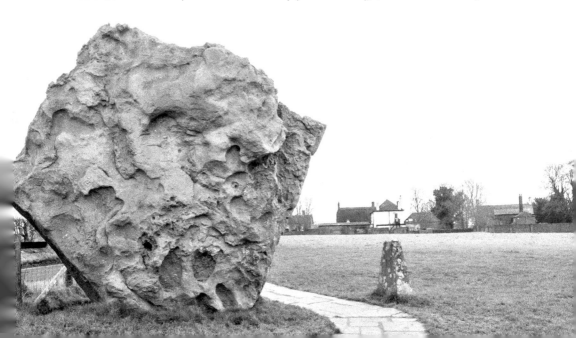

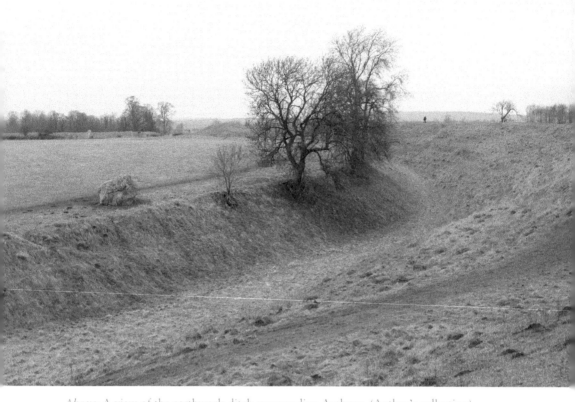

Above: A view of the earthwork ditch surrounding Avebury. (Author's collection)

Below: The gardens of Avebury Manor are as impressive as the manor itself. (Author's collection)

weighed a staggering 13 tonnes. His body was trapped in the hole that had been dug for the stone and the villagers were unable to get it out. Archaeologists finally excavated his body in 1938 and found three coins on his person dated 1320–25. In the seventeenth and eighteenth centuries a number of stones were smashed up to provide building materials for the quickly developing village, and a number of houses were constructed within the henge itself. To stop further construction ruining the site, archaeologist Alexander Keiller decided that the best way to preserve Avebury was to simply buy it. As heir to the James Keiller & Son business, he used his personal wealth to purchase 950 acres of land and lived in Avebury Manor until his death in 1955. He re-erected many of the stones and established the Alexander Keiller Museum, which feature many artefacts found at Avebury.

Located right in the centre of the village is Avebury Manor and Garden, a Grade I listed sixteenth-century manor house now owned by the National Trust and built on the site of a Benedictine priory. The house incorporated fragments of the priory into its construction, and over the years it has been subject to many alterations and extensions. The house had its gardens completely redesigned in the early twentieth century and was the subject of a BBC One television series in 2011. Visitors to the manor are encouraged to 'touch and experience' the items in the rooms in order to better understand life in the sixteenth century.

3. Battlesbury Camp

Near the town of Warminster in south-west Wiltshire are the remains of an Iron Age hill fort known as Battlesbury Camp. Covering an area of over 23 acres, the hill fort uses the natural slopes and contours as natural defence, with an impressive three lines of ditches and ramparts encircling the vast majority of the site. Based on findings within the site, it is thought that the hill fort was constructed around 100 BC, with parts possibly built on top of pre-existing burial mounds. Further excavations have shown that roundhouses and other structures were once constructed up here. Today, it is possible to freely access the site at any time of the year and take in the beautiful views.

The steep sides of Battlesbury Camp made it a formidable Iron Age hill fort. (Author's collection)

4. Boscombe Down Aviation Collection

Located in Hangar 1 on the site of the Old Sarum airfield is the impressive Boscombe Down Aviation Collection. Becoming a registered charity in 2011, the vast collection of aircraft, cockpits, replicas and equipment show the history of flight and flight testing in the UK – and particularly that of the Boscombe Down site. The site was first used by the military in 1917 when it was opened to provide a training facility for the Royal Flying Corps – the precursor to the Royal Air Force, which was founded on 1 April 1918. Between 1934 and 1937 the airfield was redeveloped as a permanent station in preparation for the Second World War, and more than doubled in size to 54 hectares. In May 1941, the base was attacked, which resulted in one hangar and two aircraft being destroyed. After the war, the airfield was used by the military until 1979 and then used by a range of private companies and flying clubs, before closing in 2019. The aviation collection, which is still open, has a range of aircraft, engines, weapons as well as a display of uniforms, medals and artefacts from the Royal Flying Corps. It is possible to explore these aircraft chassis and sit in a number of cockpits on a visit, and it is so pleasing to see that a number of restoration projects are always on the go.

A Gloster Meteor at the Boscombe Down Aviation Collection. (Courtesy of Steve Lynes CC BY 2.0)

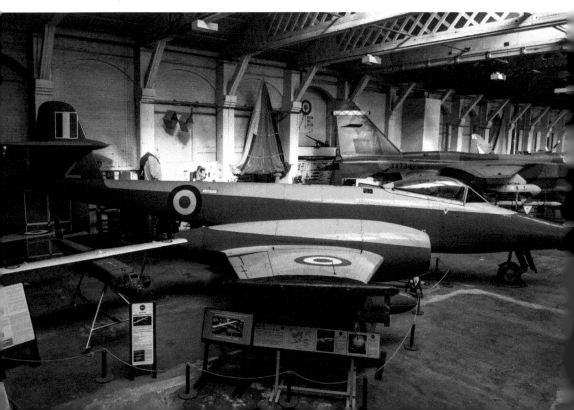

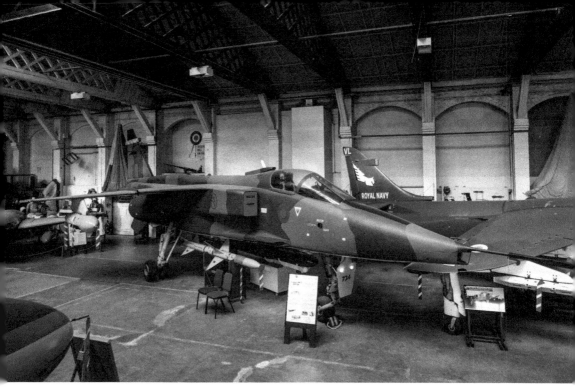

Above: A large range of aircraft are restored and on display. (Courtesy of Steve Lynes CC BY 2.0)

Below: The unique Sea Harrier FA2 – XZ457 is on display here. (Courtesy of Steve Lynes CC BY 2.0)

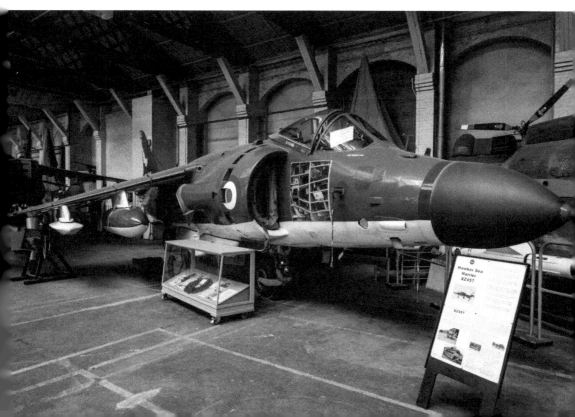

5. Bowood House

First built in 1725 on the site of an old hunting lodge, Bowood House is a Grade I listed building that has a lot of interesting history with it. The original purchaser, Sir Orlando Bridgeman, got into financial difficulties and it came into the hands of John Petty, the 1st Earl of Shelburne in 1754 where it was extended to comprise of 'the Big House' (which was demolished in 1956 due to its dilapidated state) and the 'Little House', the orangery wing, and the stables, which remain today. The 2nd Earl of Shelburne, William, was the prime minister of Great Britain (4 July 1782 to 26 March 1783) and spent his time between his London home and at Bowood House. He was created 'Marquess of Lansdowne' for negotiating peace with the new United States after the American War of Independence, and with his wealth and power he not only decorated the internal rooms with paintings and sculptures, but he also commissioned a beautiful orangery, a menagerie for wild animals and a mausoleum to be built within the grounds. However, this is not the only significant person to have been at the house. In 1774, Joseph Priestley became the first person to discover oxygen as a separate gas, and he did so in his laboratory in one of the rooms of house – still there for you to see today. The gardens at Bowood House were designed by the famous Lancelot 'Capability' Brown in the 1760s and cover over 2,000 acres. Manning's Hill Hamlet was completely submerged to create the kilometre-long lake, and it is surrounded by vast lawns and rows of mature trees. This was added to in the years that followed with a cascade, grotto, Italianate-terraced gardens and the Upper Terrace – all of which are now on the Register of Historic Parks and Gardens of Special Historic Interest in England. A Red Cross hospital was set up in the orangery during the First World War, and in the Second

A view of Bowood House and its terraced gardens. (Courtesy of Hugh Llewelyn CC BY-SA 2.0)

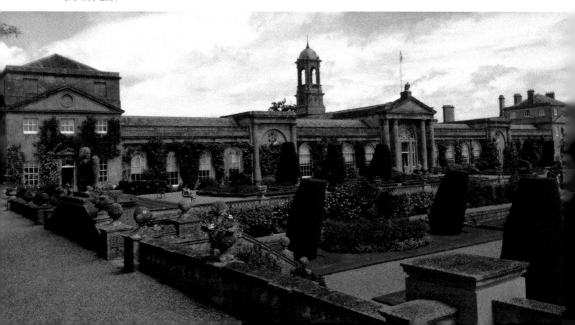

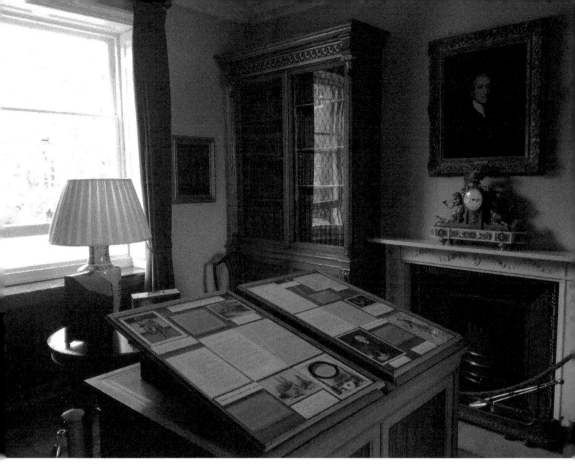

In this tiny room, Dr Joseph Priestley discovered oxygen in 1774. (Courtesy of Hugh Llewelyn CC BY-SA 2.0)

World War the 'Big House' was initially used as a school and then by the RAF. In the immediate years that followed the 'Big House' was left untouched and uncared for, and in 1955 it was in such a bad state that it was demolished, leaving only the orangery and terraces standing today. Despite this the house is still the seat of the Lansdownes, and a visit to the house and grounds are not to be missed.

6. Bradford-on-Avon, Tithe Barn and Saxon Church

The town of Bradford-on-Avon is one of the most picturesque in the county, with its canals, historic buildings and streets making it very popular with locals and visitors. Lying in the Avon Valley, the town's origins can be traced back to the Romans; they established a ford across the River Avon – hence the town's name of 'broad-ford' morphing into 'Bradford' over the centuries. The most obvious eye-catching part

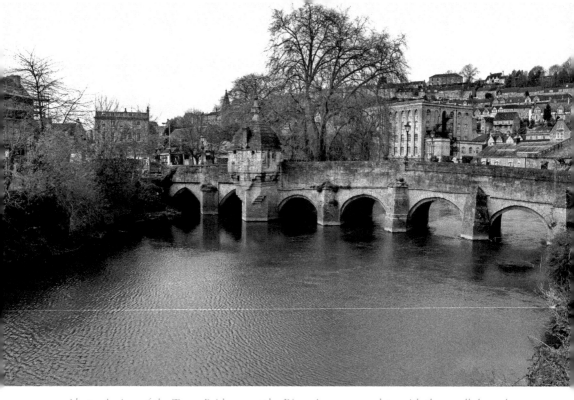

Above: A view of the Town Bridge over the River Avon – complete with the small domed building that was once the town lock-up. (Courtesy of Clive Richardson CC BY-ND 2.0)

Below: The eleventh-century Saxon church in Bradford-on-Avon. (Courtesy of Hugh Llewelyn CC BY-SA 2.0)

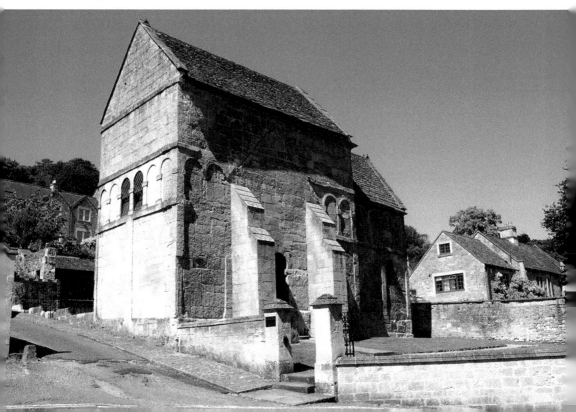

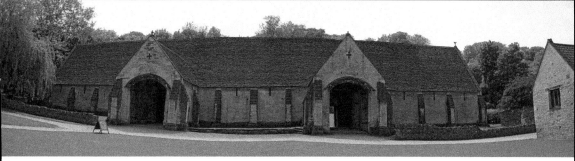

Above: The Grade II tithe barn is over 180 feet long. (Courtesy of Bill Tyne CC BY-SA 2.0)

Below: The roof of the tithe barn is supported by these glorious wooden beams. (Courtesy of Bill Tyne CC BY-SA 2.0)

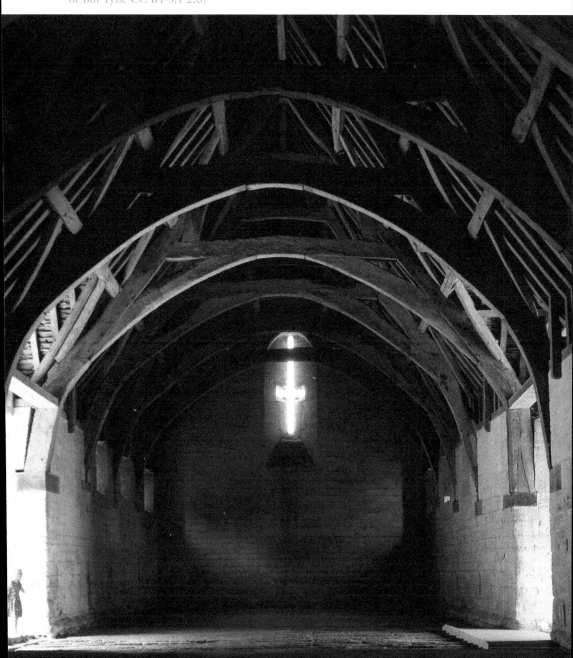

of the town is the Grade I listed beautiful Norman stone bridge that crosses the river. The town grew significantly in the seventeenth century because of the textile industry, with the river providing the necessary power for the mills. The bridge was widened and a number of buildings from this time still remain today. Those with a keen eye will notice a small domed building on the bridge – this was originally a chapel but then was later used as the town lock-up. During the English Civil War there was a small skirmish here when, on 2 July 1643, the Royalists took control of the bridge as they headed to the Battle of Lansdowne on the outskirts of Bath just a few miles away. There is a rather splendid Grade II listed tithe barn within the boundaries of the Barton Farm Country Park in Bradford-on-Avon. Constructed in the fourteenth century and used by Shaftesbury Abbey in Dorset to store the taxes paid by the townsfolk, it is over 180 feet long and around 30 feet wide. Although the abbey was dissolved in 1539, the barn was used by Barton Farm and is now owned by English Heritage and looked after by Bradford-on-Avon Heritage Trust. The town also boasts what John Betjeman thought was 'the most notable Saxon church in England'. Bradford-on-Avon Church, dedicated to St Lawrence, is thought to have been founded in the early eighth century, intended to be the resting place for relics of King Edward the Martyr. The structure was redeveloped over the years, with the majority of the building that is standing now, being built around the tenth century. Rather surprisingly, over the centuries as the town developed, the church was actually 'lost', being part of a house, a school and even a factory! It was rediscovered in the mid-to-late nineteenth century and was restored over the following decades.

7. Caen Hill locks

Located between the village of Rowde and the town of Devizes along the Kennet and Avon Canal, the Caen Hill Locks are dubbed one of the 'wonders of the waterway', and it is easy to see why. The twenty-nine locks that make up the Caen Hill Locks are one of the longest continuous flight of locks in the country, and they are split up into three distinct sections: seven lower locks from Foxhangers Wharf lock to Foxhangers Bridge lock; the most spectacular section of sixteen locks forming a steep flight up the hill; and the final six locks into Devizes. The steep terrain here means that the canal has to rise 237 feet in just 2 miles of waterway. This is no mean feat, especially considering that the locks were constructed over 200 years ago. This was the final part of the 87-mile canal, and it was the job of engineer John Rennie to come up with a solution to climbing this steep hill. A brickyard was dug to the south of the locks to make all the bricks that would be needed for this venture and the canal was such an important transport link, particularly for goods, that between 1829 and 1843 gas lights were installed to ensure the locks could be navigated at night. The railway age saw the use of the canal drop significantly and the last cargo shipment of grain went through Caen Hill in 1948 before they were closed, and the canal fell into disuse.

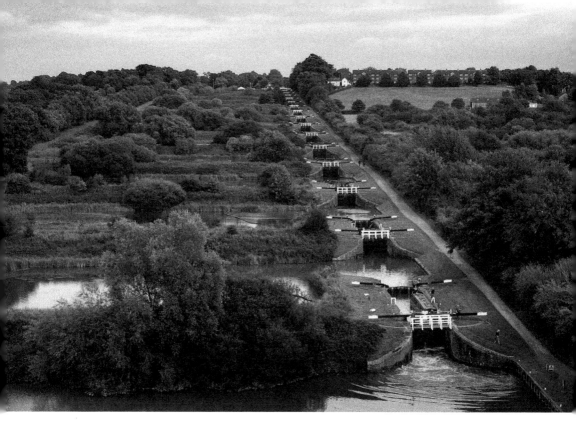

Above: A stunning aerial view of the Caen Hill Locks. (Courtesy of Dave W CC BY 2.0)

Below: Rising 237 feet in just 2 miles, it takes on average five to six hours for a barge to make it through. (Courtesy of Hans Splinter CC BY-ND 2.0)

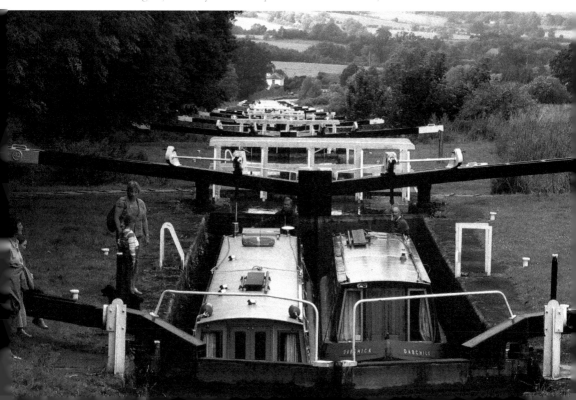

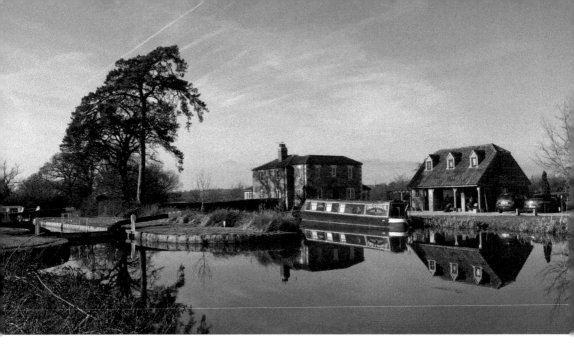

Thankfully, there was a huge effort to clean and make the canal re-navigable again, culminating in a visit by Queen Elizabeth II in 1990 to reopen it! It takes around 5–6 hours go through these locks in a barge, and they are now a scheduled ancient monument. There is a delightful welcome boat, named 'The Admiral' after Admiral Sir William O'Brien who was a key person in restoring the canal, and it is a fantastic source of information on pond dipping and walks for both adults and children. To mark the Queen's Diamond Jubilee in 2012, Caen Hill Diamond Jubilee Wood was formed – with over 30,000 trees planted – and this provides another wonderful reason to visit the area and get away from the pressures of modern life. With a range of trees, it is possible to spot fox, deer and many small mammals, as well as frogs, dragonfly and other aquatic wildlife at the new pond.

8. Castle Combe

Sitting within the Cotswolds Area of Natural Beauty, Castle Combe is a beautifully picturesque village that is actually in two parts – Castle Combe on the banks of the Bybrook River and Upper Castle Combe on the higher ground. The village takes its name from the medieval motte-and-bailey castle that once stood half a mile to the north of the village, and that now just has some earthworks and rubble remaining. Walking through the old narrow streets and houses, is it hard not to be briefly transported back in time to an era of horse and cart. With the fourteenth-century market cross, two village pumps and a whole lot of old-world charm, it is easy to see why the village has been used for numerous film and television productions,

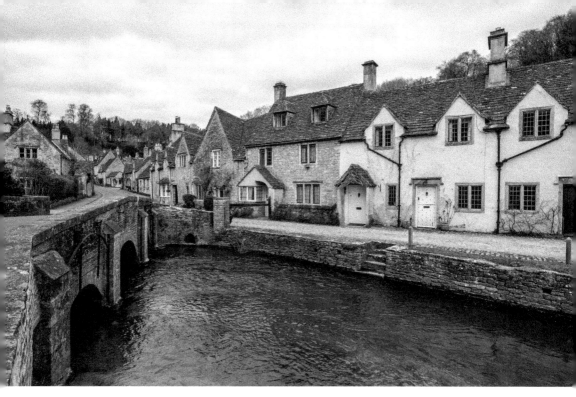

Above: It is easy to see why the village of Castle Combe has been used as a location for so many film and television programmes. (Courtesy of Andrew Stawarz CC BY-ND 2.0)

Below: The market cross and village pump. (Courtesy of Martin Pettitt CC BY 2.0)

including the 1967 musical *Doctor Dolittle*, Steven Spielberg's production of *War Horse*, and episodes of Agatha Christie's *Poirot* and *Downton Abbey*. In 1941, just to the south-east of the village, RAF Castle Combe was built on land that belonged to the Castle Combe estate. Initially used as a practice landing ground for nearby RAF Hullavington, it was extended and developed and remained open until 1948. In 1950, the outer perimeter track of the airfield was used for motor sports, and the Castle Combe Circuit remains in use to this day.

9. Chalke Valley History Festival

A true celebration of the past, the Chalke Valley History Festival only began in 2011 as humble fundraiser for the local cricket club but has since turned into arguably the finest festival dedicated to history in the world. Covering over 70 acres in Broad Chalke, the festival not only features static displays like a traditional museum but has a range of world-renowned guest speakers talking about their specialisms. From James Holland and Dan Snow to Tom Brady and Boris Johnson, you're sure to see and hear from a lot of famous faces. Whatever era of history is your interest, there is

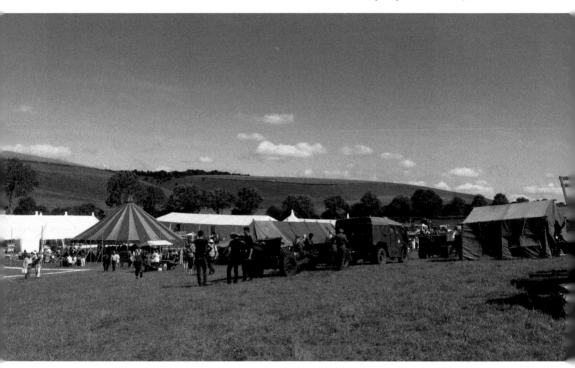

Covering over 70 acres, the Chalke Valley History Festival covers every era of history. (Courtesy of Peter Wiltshire CC BY 2.0)

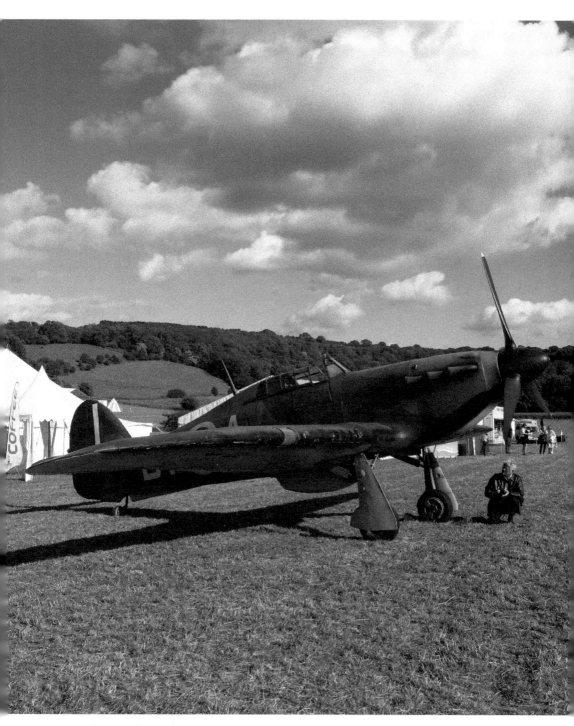

A Mk II Spitfire at the festival – always a draw to people of all ages. (Courtesy of Peter Wiltshire CC BY 2.0)

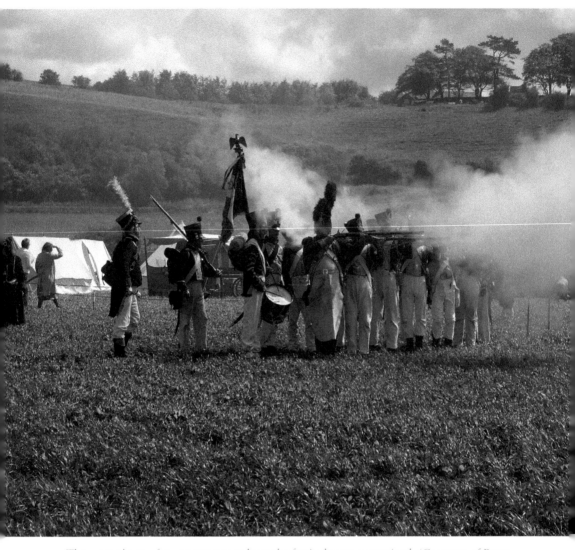

There are plenty of re-enactments to keep the festivalgoers entertained. (Courtesy of Peter Wiltshire CC BY 2.0)

likely to be a re-enactment across the week, with costumes and artefacts everywhere you look. There aren't many places where you can interact with Roman soldiers, knights from the Middle Ages or Tommies from the world wars, and the number of 'living history' displays ensures that everyone has the opportunity to look into the past and feel what it was like. What is most pleasing is the fact it also incorporates a history festival for schools, providing thousands of children and young adults with the opportunity to inquire and develop their knowledge in their own dedicated three days of displays, demonstrations and talks. A festival of national importance, this is certainly one to experience.

10. Coate Water Country Park

The Coate Water Country Park started its life as a 70-acre reservoir built in 1822 to provide the necessary water required for the Wilts & Berks Canal. Just under 100 years later the canal was abandoned, and in 1914 it was turned into a communal pleasure park, with the addition of a diving board and changing rooms. In 1935, these wooden diving boards were replaced with a 10-metre-high art deco concrete platform for people to dive from and throughout the interwar years, and indeed post-Second World War, they were used by members of the public until swimming in the lake was prohibited in 1958. The lake and park now take up over 50 hectares and because of the variety of birds that now frequent the site and breed there, as well as the wildflower meadows, it is listed as a biological Site of Special Scientific Interest. With a café, play area and splash park in addition to the nature reserve, Coate Water Country Park is a wonderful place to go and get away from it all.

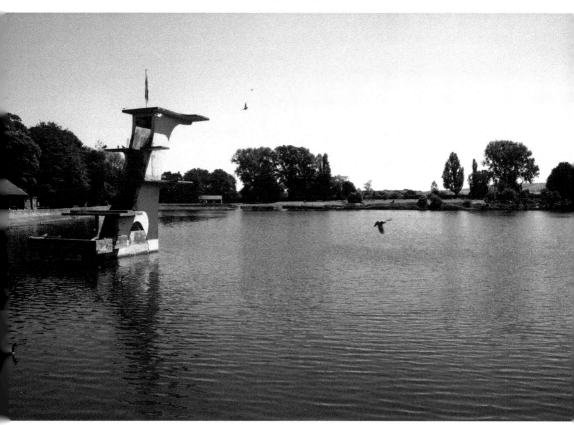

The art deco diving board, built in 1935, still remains at Coate Water Country Park. (Author's collection)

11. Cranborne Chase AONB

Covering an area of 379 square miles, the chalk plateau of Cranborne Chase is an Area of Outstanding Natural Beauty that sits over the boundaries of Wiltshire, Dorset, Somerset and Hampshire. It is not surprising that such a large area has a diverse range of characteristics – from chalky grassland and river valleys to hillsides and ancient woodland. There is a long history of human settlement and use on Cranborne Chase, with earthworks and burial mounds scattered across the length and breadth of it, and the earliest findings have been from the Neolithic age. At Knowlton (inside the Dorset border), there are the remains of a Norman church standing at the centre of a late Neolithic henge monument. At Oakley Down barrow cemetery, a site described as 'the finest group of round barrows', it is still possible to easily make out the ancient disc barrows gouged into the landscape, even though they are surrounded now by the A354 road on the west and the Roman 'Ackling Dyke' on the east – which was actually built through the perimeter of the largest disc barrow. A number of Iron Age settlements are on the high grounds of the Downs, with the large Badbury Rings Iron Age hill fort the most impressive. Covering an area of 41 acres, a survey carried out in 1998 recorded twenty-eight potential hut sites within the ramparts – a location that was defended by multiple ditches – and exploring this complex is awe inspiring for its solitude and scale. Another large defensive ditch, the Bokerley Dyke, was constructed by the Romano-British to keep

Stunning views are guaranteed while on Cranborne Chase. (Cortesy of Jack Pease Photography CC BY 2.0)

Oakley Down barrow cemetery on Cranborne Chase. (Courtesy of Jim Champion CC BY-SA 2.0)

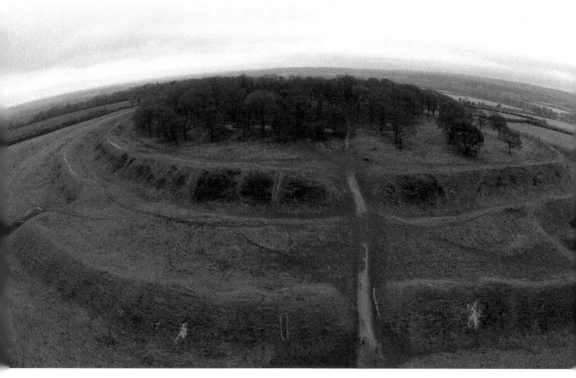

A spectacular view of the Badbury Rings Iron Age hill fort. (Courtesy of Mark Way CC BY-ND 2.0)

the Saxons out. This whole site has been recorded as a biological Site of Special Scientific Interest, with many of the woodland areas being centuries old and have a huge range of flora and fauna spread across it. It is possible to go off the beaten track here, spending all day walking and exploring nature without even coming into contact with anyone else. The solitude and natural splendour of this location is worth exploring and, being so vast, it is possible to return time and again without seeing the same part twice.

12. Devizes – Wiltshire Museum

Most proud counties have a museum dedicated to its heritage and history, and Wiltshire is no different. The Wiltshire Museum, located in the town of Devizes, is an independent charity run by the Wiltshire Archaeological and Natural History Society. The museum does everything it should do, from award-winning displays with unique artefacts covering a range of Wiltshire's history, to child friendly access and educational learning opportunities. It features what has been called 'Britain's best Bronze Age archaeology collection'. The museum aims to tell 500,000 years of the county's history, and the collections they have here are

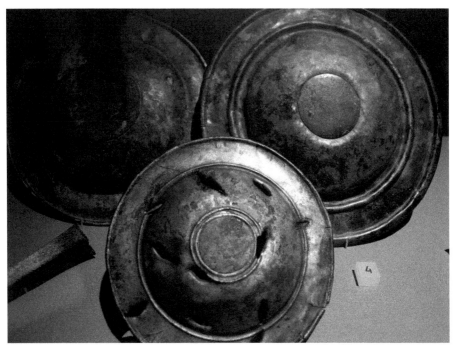

Some remarkable shields are just some of the items on display from the Melksham Hoard. (Author's collection)

of national importance. The museum has some good reconstructions that help to detail life in prehistoric Wiltshire, along with arrowheads, daggers, pottery and a whole host of incredible finds from the region. Stonehenge takes centre stage, of course, and one of the most interesting displays is that of the 'Bush Barrow Chieftan' who died around 2000 BC. He was buried under a barrow on a ridge that overlooked Stonehenge along with all of his prized possessions, such as daggers, axes and a ceremonial mace. One of the daggers is set with thousands of tiny gold studs, each around 1 mm long, and this gold dating from the time of Stonehenge demonstrates the remarkable attention to detail and craftsmanship shown by craftsmen in the Bronze Age. There is also an exquisite dagger made of flint, known as the Stonehenge Dagger, which is thought to have been created from around the same time. However, there is much more to Wiltshire than just Stonehenge, and it is pleasing that the museum devotes space to other aspects of the county's heritage, including history of Devizes itself (such as details of the town's eighteenth-century annual cucumber feast), famous people from Wiltshire's past, and artefacts from other prominent finds in the region such as the Cunetio hoard (nearly 55,000 Roman coins) and a beaker found in the chambers of the West Kennet Long Barrow. For the children, the museum gives them the chance to follow 'Archie and Ollie' around the displays in an interactive way, where they get to examine items under a microscope and even dress up in clothes from some of the different time periods – always great fun!

13. Devizes Castle

The town of Devizes developed around a Norman motte-and-bailey castle that was built here in 1080 in the aftermath of the Norman Conquest. The castle must have been quite substantial as it held Robert Curthose (eldest son of William the Conqueror) as a prisoner in 1106, where he remained for twenty years. Records indicate that the wooden structure burnt down in 1113 but was quickly rebuilt in stone by Roger of Salisbury in 1120. In 1141, the town was granted a charter permitting regular markets and these were held in the space that is now outside St Mary's Church, which quickly became the centre of the town. During the twelfth century civil war between Stephen of Blois and Matilda, known as the Anarchy, the castle switched hands many times. Over the next 200 years the town continued to grow as a centre of commerce for craftsmen and traders, with wheat, wool, cheese and butter being increasingly important. The castle remained the focal point for law and order over the town for the next few centuries but that changed in the aftermath of the English Civil War. During the war, in 1643 Parliamentarian forces besieged the Royalist troops inside until they were relieved by a force from Oxford, which ensured Devizes and its castle remained in Royalist hands. However, in 1645 Oliver Cromwell attacked the castle with 5,000 men and heavy artillery, forcing those inside to surrender and ultimately resulting in the castle being almost totally destroyed on the orders of Parliament in 1648, with the stone being reused

Above: The modern market square in Devizes. (Author's collection)

Below: The gatehouse to Devizes Castle. (Courtesy of Hugh Llewelyn CC BY-SA 2.0)

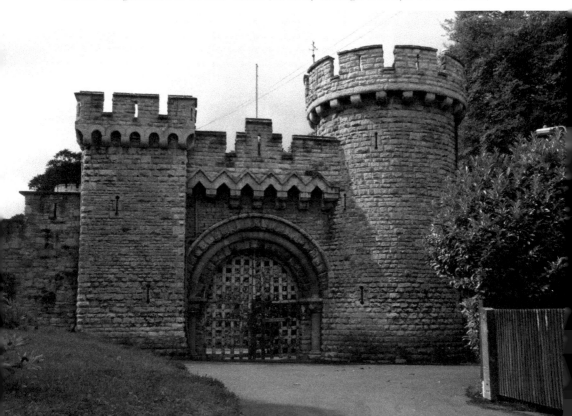

for buildings in the town. The footprint ruins of the castle lay in the ground until 1838 when Devizes tradesman Valentine Leach purchased the land and built his own Victorian-era castle over the coming decades. The current castle, still privately owned but now a Grade I listed building, sits in over 2 acres of land with turrets, towers and castellations, and gives us a tantalising glimpse of what the original castle might have been like.

14. Dinton Park and Philipps House

Just a few miles west of Salisbury lies the village of Dinton and this National Trust-owned property. Philipps House, and its park, are Grade II listed and cover around 250 acres of land. The house standing today was constructed in 1816 for William Wyndham on the site of an already demolished seventeenth-century house named Dinton House. It is built of Chilmark stone, a local stone that was also used for the building of Salisbury Cathedral. It is also two storeys high and set out in a symmetrical design. The centrepiece to the house is a large square hall with an

A view across Dinton Park. (Author's collection)

imperial staircase that leads up to the first floor. A hundred years after it was built the estate was bought by Bertram Philipps, who decided to name the house after himself. He was High Sheriff of Wiltshire in 1923 and in 1936 he and his wife moved into the nearby Hyde's House and leased the main house to the YMCA. The Second World War saw the United States Army Air Force billeted on the parkland in front of the house and in 1943 Bertram Philipps gave the house and parkland to the National Trust. Today, the house is not open to the public as it is leased out privately, but Dinton Park is open to all and is a thoroughly enjoyable place to visit.

15. Great Chalfield Manor

Described as 'one of the most perfect examples of the late medieval English manor house', the moated manor house at Great Chalfield was originally constructed over 500 years ago in 1465–80 for Thomas Tropenell. The main front entrance is symmetrical, and it is interesting to note that the nearby church was once only accessed by going through the house's gatehouse and forecourt – perhaps demonstrating who had the authority in the village. Over the centuries, the house was passed into the Eyre and Neale families, with the later commissioning some

Great Chalfield Manor has some stunning gardens. (Author's collection)

Above: Ivy hangs over the main
gate. (Courtesy of Red Skelington
CC BY-SA 2.0)

Right: The beautiful stained-glass
window in the chapel. (Courtesy of
Red Skelington CC BY-SA 2.0)

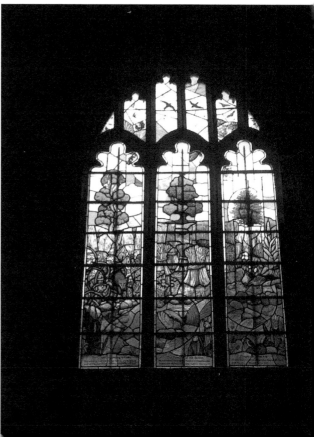

substantial work to be carried out in the nineteenth century. The house was reduced in size and the great hall was adapted to become part of the farmhouse, losing what was once a very ornate ceiling. At the turn of the twentieth century George Fuller MP purchased the estate, and with the help of his son they restored and refurnished the property and gardens. In 1943, the National Trust was given the property, but the great-grandson of George Fuller still lives there with his family, meaning that house tours are only available at fixed times and must be escorted by a guide. Due to its age and importance to the area the house is a Grade I listed building, while the gardens are Grade II listed. It is easy to imagine the house being the focal point of village life of those years ago, with the church and other buildings being close by, and it is partly because of this that it has been used by film and television crews over the years for locational shooting.

16. Kennet & Avon Canal

The 87-mile Kennet and Avon Canal was the result of centuries of thinking of creating an east to west waterway across southern England. First thought about in 1558, the idea was to link the rivers Avon and Thames, who at their closest are only a few miles apart thanks to their tributaries. In 1626, a survey was done where it was noted that the land between the two was level and that a canal could be dug in order to provide a new route to get goods via water from Bristol to London without having to navigate through the English Channel. But that was as far as things went until 1718, when work began on making the River Kennet navigable from Reading to Newbury, and this 11-mile stretch opened in 1723. In 1729, the stretch of River Avon between Bristol and Bath was recut to make it navigable, and although these two pieces of engineering had been done independently of each other, it ultimately led to a 1788 plan to create a 'Western Canal' to link the two. With the prospect of improved trade and communication for the towns it would pass, engineers drew up additional plans in 1793 and renamed it the 'Kennet and Avon Canal' so as not to cause confusion with the 'Grand Western Canal' being built between Somerset and Devon. A year later construction began, and it was finally completed and ready to open sixteen years later in 1810. It was some feat of engineering, with pumping stations being built at Claverton and Crofton in order to ensure the canal had the water supply it needed, as well as the Bruce Tunnel, aqueducts at Dundas and Avoncliff, and of course the impressive Caen Hill Locks near Devizes. Parts of the canal opened before this final piece of engineering was completed – with horse-drawn carts carrying the goods up the hill to barges waiting at the top, until the sixteen locks meant that one barge could complete the 87-mile trip by itself. By 1818, around seventy 60-ton barges were working along the length of the canal, with coal and stone being the main cargo. It took between three and four days to travel the length of the canal, with five to six hours of that time needed to navigate the Caen Hill Locks. The canal

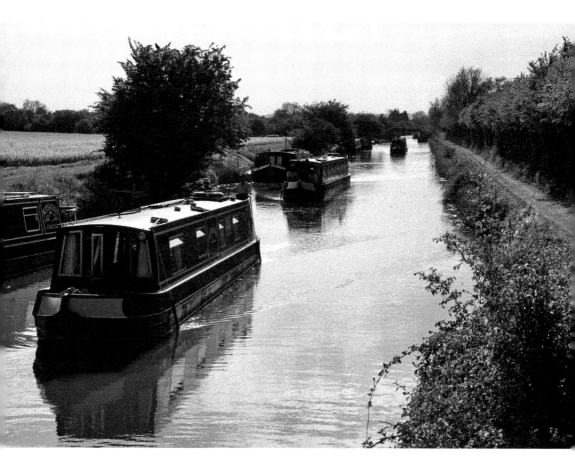

Above: The Kennet &
Avon Canal is now busy
with pleasure barges.
(Courtesy of
Clive Richardson
CC BY-ND 2.0)

Right: There are 87 miles
of waterways. (Courtesy
of Roland Turner
CC BY-SA 2.0)

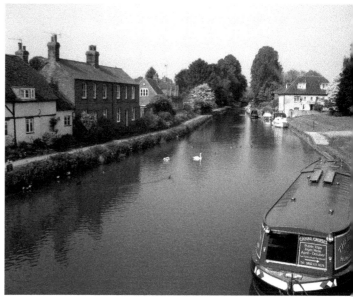

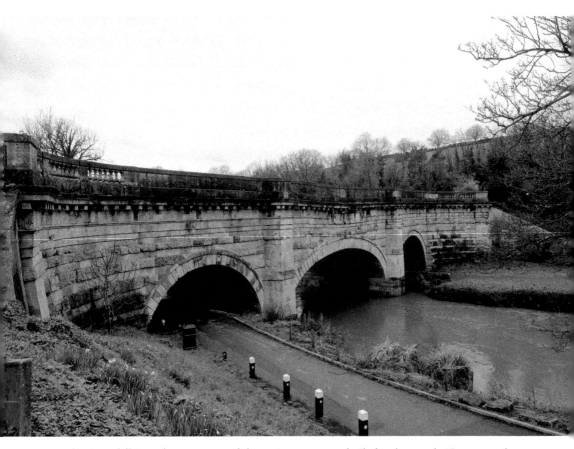

The Avoncliff Aqueduct was one of the major structures built for the canal. (Courtesy of Richard Szwejkowski CC BY-SA 2.0)

remained incredibly busy and profitable for the next two decades, but the writing was on the wall in 1841 when the Great Western Railway opened. Over the coming decades the waterway traffic fell and by 1877 the canal was running at a loss. As cargo trade declined a few pleasure boats began to use the canal, but due to poor maintenance various sections became closed and out of bounds. During the Second World War, a number of pillboxes were positioned along the canal as this man-made object became part of GHQ Line Blue – a stop line to hold up a potential German invasion, and most of these are still visible today. Thankfully, despite the poor condition of the canal, a number of fundraising activities began along with grants and help from local companies, which eventually saw the entire canal restored and officially reopened in August 1990 by the Queen. Today, the canal is a heritage tourism destination, with boats and barges regularly punting up and down stream. The summer months in particular are busy, as people look to escape the towns and cities for the breeze on the water. There is a Canal Museum at Devizes Wharf, and cycling, walking and fishing along the towpaths are worth doing, not just for the number of riverside tea rooms and pubs, but also for the

wildlife. There are a number of Sites of Special Scientific Interest along the 87-mile stretch, with over 100 species of bird being recorded, including some that are very rare. The size of the canal ensures that it is possible to visit time and again, and still see something new every time.

17. Lacock

Lacock is a small village near Chippenham that attracts thousands of visitors every year due to its unspoilt appearance. Despite having a population of just over a thousand, a lot of the village is actually owned by the National Trust, and there are plenty of ways to soak up its old-word beauty and charm. Originally mentioned in the Domesday Book, Lacock grew in size thanks in part to the building of Lacock Abbey in 1232 and the fact that the village was one of the

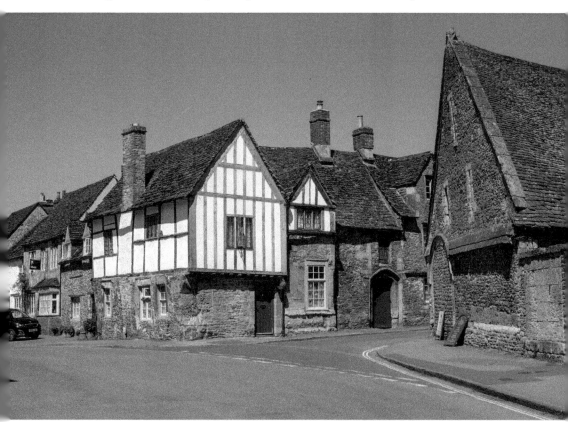

The old-world charm of Lacock. (Courtesy of Clement Larrive CC BY-SA 2.0)

only crossing points over the River Avon until the eighteenth century. During the Middle Ages, the village was granted a market because of its woollen industry, which remained a strong source of income for the coming centuries. In the aftermath of the Dissolution of the Monasteries (1536–41) the abbey and its estate (the village) were sold off to Sir William Sharington, who was High Sheriff of Wiltshire, and later came into the hands of the Talbot family by marriage. Fortunately, the 280 acres of the estate, including the abbey and village, remained together, and this was all given to the National Trust in 1944. The majority of the houses in Lacock are from the eighteenth century (some even earlier), while the Grade I listed Church of St Cyriac and a tithe barn date from the fourteenth century. Aside from Lacock Abbey (which is a gem in itself!), other notable structures include the Grade I listed Bowden Park and Bewley Court, the sign of the Angel (formally a house, now a pub), the late medieval village cross, a pair of late medieval bridges that carry the Bowden Hill road over the River Avon, and a sixteenth-century house that was once part of the abbey's water supply. The village is a real step back in time that is worth exploring. The main street and shops ooze character and getting lost down the back streets make you feel like you are in a period drama – somewhat aided by the fact that Lacock has been used in a number of television shows and films, including *Downton Abbey* and *Harry Potter and the Philosopher's Stone*.

18. Lacock Abbey

Obviously located in the village of Lacock, the abbey was founded as long ago as the thirteenth century by the Countess of Salisbury as a nunnery for the Augustinian order. Dedicated to St Mary and St Bernard, it was founded in 1229 and dedicated in 1232 when the first nuns came here. Throughout the Middle Ages the abbey and its estate, which includes the village, prospered due to the rich fertile farmlands it owned, providing a good income from wool, which was sold in Lacock's marketplace. Its fortunes changed, like most other religious sites, in the mid-sixteenth century, with Henry VIII's Dissolution of the Monasteries. Sold to Sir William Sharington, the High Sheriff of Wiltshire, for £783 in 1540, he wanted to build a country house on the cloister court, so the abbey church was demolished and its stone was used to extend the abbey into this rather grand house, building the living accommodation on top of the cloisters. It is said he sold the church bell to fund a bridge over the River Ray and in around 1550 he added an octagonal tower. It is interesting to note that the bedchambers in the new residence were named after the individuals who stayed in them regularly. During the English Civil War Royalist troops were garrisoned here and fortified it by constructing some earthworks around the perimeter as a defensive measure. However, within days of Oliver Cromwell's capture of Devizes in September 1645 the troops here surrendered to the Parliamentarians without any bloodshed or slighting of the abbey. The abbey, like the rest of the 280 acres of the

Above: The whole area around Lacock Abbey is like taking a step back in time. (Courtesy of Barry Skeates CC BY 2.0)

Below: A tantalising glimpse of the abbey. (Courtesy of Chris Shervey CC BY 2.0)

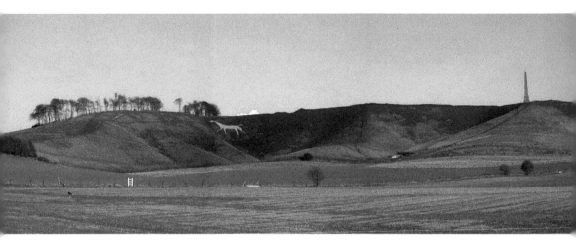

The Lansdowne Monument and the Cherhill White Horse. (Courtesy of MacFodder CC BY-SA 3.0)

estate, came into the hands of the Talbot family, who gave it to the National Trust in 1944. Today, the ground floor of the abbey contains the Fox Talbot Museum, which celebrates the life of inventor William Henry Fox Talbot, who created in 1835 what might be the earliest surviving photographic camera negative. The Grade I listed abbey, just like the village, has been used in numerous television and film productions, perhaps most noticeably in *Harry Potter and the Sorcerer's Stone* and *Harry Potter and the Chamber of Secrets*. Together with its village, Lacock Abbey is a beautiful destination that is worth visiting.

19. Lansdowne Monument

Overlooking Cherhill, the Grade II listed Lansdowne Monument was erected in 1845 and dominates the landscape – being seen for miles around. The 38-metre stone obelisk was the dream of Henry Petty-Fitzmaurice, the 3rd Marquess of Lansdowne. A British statesman who was Home Secretary and Chancellor of the Exchequer during his political career, he commissioned renowned architect Sir Charles Barry (best known for his role in rebuilding the Houses of Parliament and remodelling Trafalgar Square) to design a fitting memorial for his ancestor, Sir William Petty. Alive over 200 years before this, Sir William Petty was an economist, physician, scientist and philosopher who came to prominence while serving Oliver Cromwell. He was the great-grandfather of British Prime Minister William Petty-Fitzmaurice, who was the father of Henry Petty-Fitzmaurice. The monument was completed on time and bears the inscription: 'A true patriot and a sound philosopher who, by his powerful intellect, his scientific works and indefatigable industry, became a benefactor to his family and an ornament to his country.' The monument was

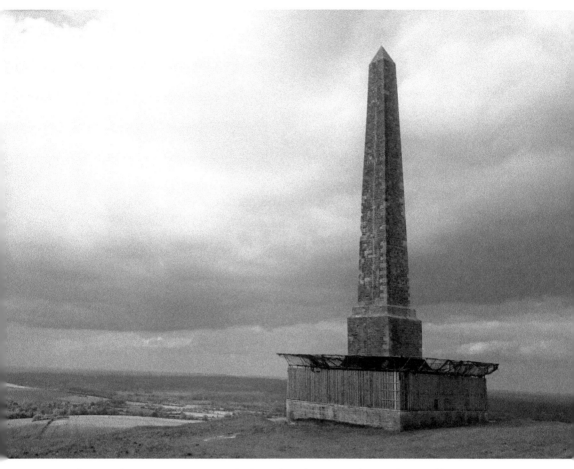

The Lansdowne Monument overlooks miles of countryside. (Author's collection)

restored by the National Trust in 1990 and a protective fence was erected to prevent future damage by members of the public who tried to climb it. With the Cherhill White Horse nearby, this is a delightful place to escape to and spend time in the great outdoors with some staggering views.

20. Littlecote Roman Villa

The Romans conquered most of Europe, including the majority of Britain, so it is unsurprising that evidence of their rule can be found across the country. Here in Littlecote Park are the remains of a Roman villa and, arguably, some of the finest mosaics in England. Originally, it is thought that this settlement was begun by the

military in order to protect one of the crossing points over the River Kennet. It is likely that this was short-lived, being replaced by farming huts in approximately AD 70, and over the next century or so these too were replaced with one rather grand villa. Archaeologists note a significant rebuild on the site in AD 270, with a number of mosaics being put down in the wings of the villa, and workshops, barns and a gatehouse being on the same site. Fast-forward 100 years and the agricultural aspects of the site were replaced with more religious ones, with the barn being converted into a courtyard, a hall and bath suite being constructed, and an altogether more elaborate 'Orpheus mosaic' being laid on the floor. This mosaic, which is still in situ, depicts Orpheus, Bacchus and Apollo and leads archaeologists to believe that the development of this complex is linked to the Pagan revival under Julian the Apostate around AD 361–63. It wasn't long after this that the vast majority of the buildings on-site fell into disrepair. It is thought that in around AD 400, shortly before the Romans withdrew from Britain, the site was vacated, and it is likely

Little remains of the Roman villa at Littlecote. (Author's collection)

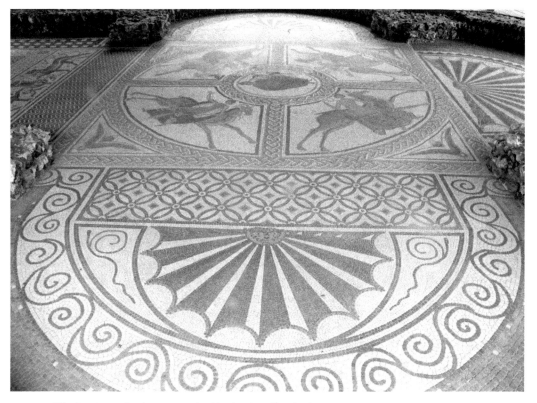

The intricate Orpheus mosaic. (Author's collection)

that all materials that were useful were taken by the locals and used in their own building projects. Over the next 1,000 years the land gradually reclaimed the villa site, until the mosaics were discovered by the steward of the Littlecote Park estate in 1727. Today, the stone footprint of the villa and the glorious mosaics are in situ and available for all to see. Set in such peaceful surroundings, when visiting it is possible to imagine what life would have been like back in Roman Britain and marvel at the craftsmanship required to create such stunning mosaics.

21. Longleat House

What can be written about Longleat that hasn't been done already? Known by millions around the world, the Longleat estate sits just inside the Wiltshire border and originally started life as an Augustinian priory. However, that was all to change as Henry VIII disbanded monasteries, priories, convents and friaries in England during his infamous Dissolution of the Monasteries, resulting in the Longleat estate

being bought for £53 in 1541 by Sir John Thynn. It is known that in April 1567 the original house, Longleat Priory, caught fire and burnt down. A replacement house, now widely regarded as one of the finest examples of Elizabethan architecture in Britain, was completely built in just twelve years by 1580. Sir John was the first of the Thynne 'dynasty'; the family have done much to build up this incredible estate over the centuries, and they still own it today. Sir James Thynne (1605–70) employed the great Sir Christopher Wren (better known for rebuilding fifty-two churches in the City of London after the Great Fire in 1666, including St Paul's Cathedral) to do modifications to the house, including designing the Best Gallery, Long Gallery, Old Library and chapel. It is around this time that the house's large book collection was started, and the formal gardens, canals and fountains were built in the grounds. In the mid- to late eighteenth century, Capability Brown was asked to replace the formal gardens with a landscaped park that included dramatic drives and roads. During the Frist World War, the house was used as a temporary hospital, and during the Second World War it became the evacuated Royal School

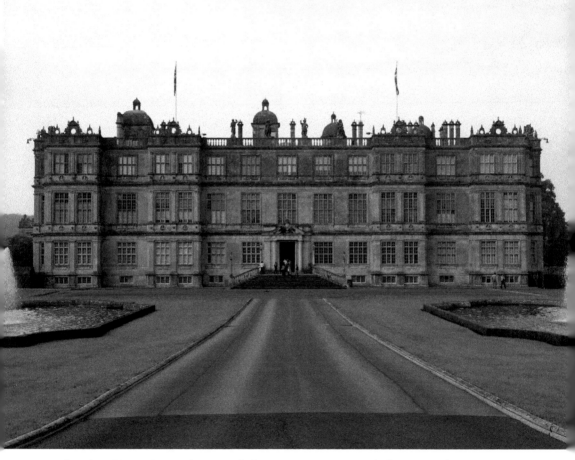

Longleat House has to be one of the most stunning stately homes in the country. (Courtesy of Karen Roe CC BY 2.0)

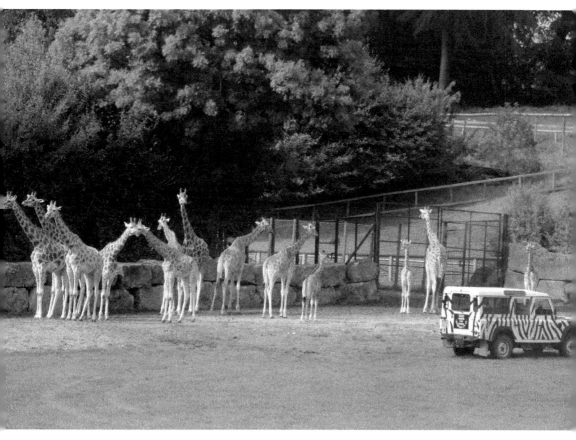

Famous for its Safari Park, it is possible to see a number of exotic creatures here. (Courtesy of Karen Roe CC BY 2.0)

for Daughters of Officers of the Army, with an American hospital also being constructed in the grounds. In 1947, in order to allow Longleat itself to survive, large parts of the marquess' estates were sold, and in 1949 Longleat became the first stately home in Britain to be opened to the public on a commercial basis. Since then, the 9,800-acre estate has long been one of the top British tourist attractions and is open from mid-February to the start of November each year. Longleat Safari Park opened in 1966 as the first drive-through safari park outside Africa. It is home to over 500 animals, including giraffe, monkeys, rhinos, lions, tigers and cheetahs. The house is set in 1,000 acres of parkland, landscaped by Capability Brown of course, with 4,000 acres of farmland and 4,000 acres of woodland (which includes a Center Parcs holiday village). With so much to see inside the house, and out in the estate, it is impossible to do it all in just one day. It is interesting that the Longleat hedge maze is considered the world's longest, with over 1.5 miles of pathway. Whether you come for the architecture, the house's place in history (the guest books shows the signatures of the Queen and Prince Philip, and that of George VI and Elizabeth – the Queen Mother), or the vast safari park, it is guaranteed that you will make memories that will last a lifetime.

22. Ludgershall Castle

The ruins of Ludgershall Castle in the far east of the county are all that are left of a castle built in the eleventh century by Edward of Salisbury, Sheriff of Wiltshire. By around 1100 it went into the possession of the Crown and a man called John Marshal (recorded as the king's castellan) is said to have strengthened the structure. At this point a northern enclosure was constructed on-site, which contained all the important buildings, including a great hall and a tower with royal living quarters. King John then updated the site, transforming it from a castle to keep the population in check, to a hunting lodge in 1210. Ludgershall was an important place in medieval England, with King John's son, Henry III, using it regularly. By the fifteenth century the castle had fallen into disuse and, like many buildings that had outlived their purpose, the vast majority of the stone was taken and used for other projects. The site was only excavated for the first time between 1964 and 1972, and was then listed as a Scheduled Ancient Monument in 1981. Significant earthworks remain, although they have been greatly altered by quarrying on the site, and parts of three large walls are left for you to visit today.

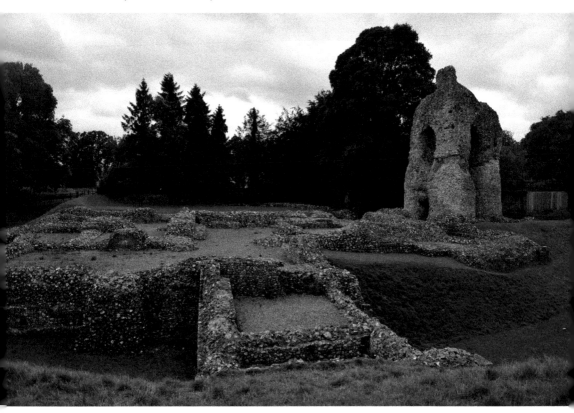

The ruins of Ludgershall Castle. (Author's collection)

23. Malmesbury Abbey

It is thought that the site for what is now Malmesbury Abbey was first chosen way back in seventh century by an Irish monk named Maildubh, who established a hermitage and taught local children. Towards the end of the seventh century the area was conquered by the Saxons and Malmesbury Abbey was founded as a Benedictine monastery around the year 676. Over the centuries the abbey developed a reputation for academic learning under the rule of abbots such as Aldhelm, and by the eleventh century it is said to have contained the second largest library in the whole of Europe. At the beginning of the eleventh century, the monk Eilmer of Malmesbury attached wings to his body and flew from a tower in what was one of the first human attempts at human flight. It is said that he flew for over 200 metres before landing and breaking both legs. The Domesday Book of 1086 lists the abbey and its estates, and over the next century the abbey buildings that we see now were largely completed. By 1180, a tower was created that had a spire on top of it that reached up 131 metres. For a building that was built so long ago, the abbey's history is actually quite well documented – thanks of course to the monks being able to read

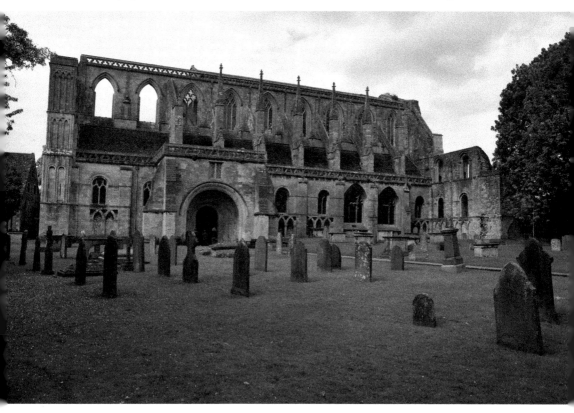

The south elevation of Malmesbury Abbey. (Courtesy of Hugh Llewelyn CC BY-SA 2.0)

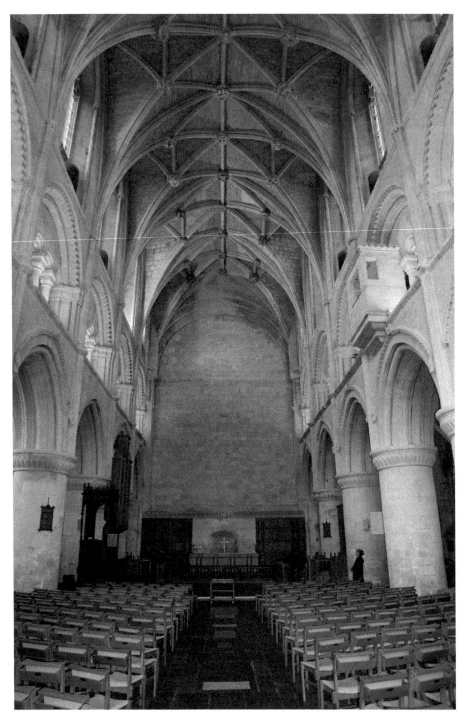

The Norman nave with arcades. (Courtesy of Hugh Llewelyn CC BY-SA 2.0)

and write – and therefore the abbey's key moments have been documented. Over the next 350 years the abbey cemented its position of power by owning around 23,000 acres in its twenty parishes – these made up the Malmesbury hundred. Like all religious buildings in the country, the Dissolution of the Monasteries in 1539 by Henry VIII had a massive impact on it, and the abbey and all its lands were sold off to a rich merchant named William Stumpe. He actually returned the abbey church to the town for continuing use as a parish church – possibly saving it from being torn down and its stone reused – and he filled the abbey buildings with looms for his cloth-weaving business. The west tower fell in a storm around 1550, destroying much of the church, including two-thirds of the nave and the transept, leaving less than half of the original building standing today. The English Civil War also left its mark at Malmesbury. The village and its abbey is said to have changed hands between the Royalist and the Parliamentarians as many as seven times, with the abbey being fiercely fought over. The south, west and east sides of the abbey walls still have marks left by the bullets. Today, the Grade I listed Malmesbury Abbey is still in full use as the parish church of the village of Malmesbury and is dedicated to St Peter and St Paul. Visiting such a grand building with so much history within its walls is a remarkable experience, and the fact that the abbey is still used to this day for its intended purpose certainly adds an extra layer. The size of the abbey and its ruins are staggering – more so when you remember these only represent half of the original structure. It would have been a truly breathtaking sight when it stood in its entirety, and walking around the peaceful and sedate grounds gives you a chance to appreciate its 1,300 years of history.

24. Marlborough

The market town of Marlborough sits on the Old Bath Road – the old main road from London to Bath – and it is a town with some quite surprising history. Human remains found at the 19-metre Marlborough Mound, now in the grounds of Marlborough College, show that there has been a settlement in this area for a long time, and the Mildenhall Hoard, a 1978 find of a staggering 54,951 low value Roman coins just a few miles out from the town, only backs this up. In the aftermath of the Norman Conquest, William the Conqueror assumed control of the Marlborough area in 1067 and built a wooden motte-and-bailey castle, sited on the prehistoric 'Marlborough mound'. As a result, the town is noted in the Domesday Book of 1087 and the castle was then completed around 1100. William established a mint in the town, nearby Savernake Forest became a royal hunting ground and the castle became an official royal residence. Henry I spent Easter in the town and Henry II often stayed at the castle, which was then strengthened in stone in 1175. King John was married here and spent time in Marlborough, where he established a Treasury, and granted weekly markets to be held on Wednesdays and Saturdays – something that continues to this day. Henry III married in the town and even held Parliament here in

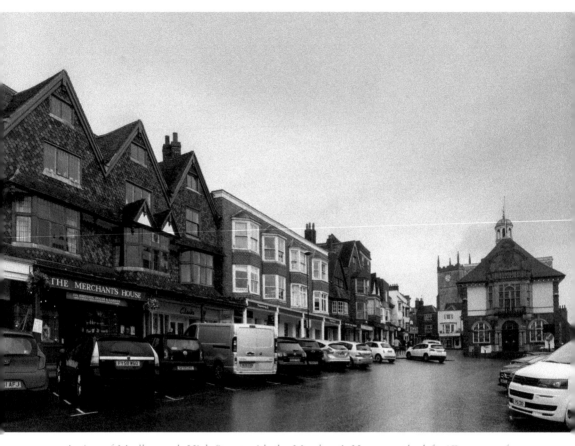

A view of Marlborough High Street with the Merchant's House on the left. (Courtesy of Derek Winterburn CC BY-ND 2.0)

1267. Sadly, by the end of the fourteenth century the castle had lost its importance, fallen into disrepair and was then taken over by the Seymour family. Like most notable towns the English Civil War had an impact on the local population. The town was Parliamentarian despite the Seymour family and the remains of the castle being loyal to the king, and as a result in 1642 Royalist troops infiltrated the town down its small backstreets and alleyways. They looted what they could, set many buildings on fire, and marched over 100 people to Oxford in chains. Only a few years later, disaster struck the town again: this time in the form of the Great Fire of Marlborough, when on 28 April 1653 a fire started in a tanner's yard and burnt the Guildhall, St Mary's Church, the County Armoury, and 244 houses to the ground in just four hours. On the northern side of the high street is one of the town's most prominent buildings – the Merchant's House, which was constructed following the Great Fire of 1653. It belonged to a silk merchant and retains its original room layout, with one room being painted in a striped pattern, silk hangings and wall paintings. Fire swept through the town again in 1679 and once more in 1690, but somehow this building survived. The town centre is still a busy place today, which is somewhat fitting considering its market trading past.

25. Netheravon

The village of Netheravon was once the site of a Roman villa, now long since gone and with very little discernible evidence due to the site now being occupied by an army barracks. It was even mentioned in the Domesday Book, along with the church of All Saints, which is still standing. In 1734, a hunting box was built for Henry Scudamore, Duke of Beaufort, in what is now known as Netheravon House. The three-storey house is built in brick and has five bays to its south entrance front, a large stable block and an eighteenth-century dovecote that has 700 nesting boxes. In 1898 a whole swathe of land in the area was bought by the War Department, including Netheravon House and almost the whole of the Netheravon parish. In 1904, a cavalry school was established under the sponsorship of Major General Robert Baden-Powell as the Inspector General of Cavalry. Just on the outskirts of the parish, Netheravon Airfield was created in 1913 for the Royal Flying Corps north-east of Coulston Camp and later became known as RAF Netheravon, where it was the home of No. 1 Flying Training School RAF from 1919 until 1931. During this time, in 1922 the cavalry school amalgamated with the Royal Artillery Riding Establishment in Northamptonshire, leaving the location to be taken over by a Machine Gun School, becoming a Small Arms School Corps in 1926. Over the coming decades this was developed to include all support weapons in general, becoming the 'Support Weapons Wing' of SASC. The Second World War saw the airfield more widely used for training with glider and parachute activity from 1941, with Netheravon House becoming the officers' mess. The Support Weapons Wing remained operational until 1995 and the airfield was used by the military up until 2012. Netheravon House, stables, grounds and dovecote are all Grade II listed.

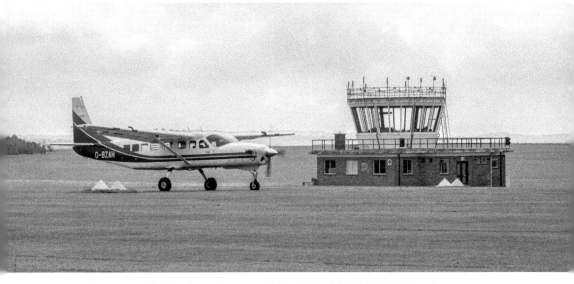

Netheravon Airfield today. (Courtesy of Jamie Franklin CC BY-ND 2.0)

26. North Meadow National Nature Reserve

The North Meadow National Nature Reserve at Cricklade is a huge hay meadow that is nearly 25 hectares in size. Designated a National Nature Reserve and a biological Site of Special Scientific Interest, it is located between the Thames and the Churn rivers, and because of this suffers from regular winter flooding, which creates a unique habitat for the fritillary flower. The meadow is grazed between 12 August and 12 February each year and is then cut for hay no earlier than 1 July. The land is managed by Natural England, and information suggests that this pattern of land use has been used for many centuries and has resulted in a rich grassland flora and fauna, with over 250 species living here – of particular interest is the fritillaria meleagris. This meadow has the largest British population of the snake's-head fritillary, with around 500,000 fritillaries flowering each year, which represents approximately 80 per cent of the British population. There is a large range of biological diversity of the site thanks to the fact it is surrounded by rivers, streams and drainage ditches, which are perfect for grass, flowers, insects, dragonflies, butterflies and birds, making this a truly natural gem of Wiltshire.

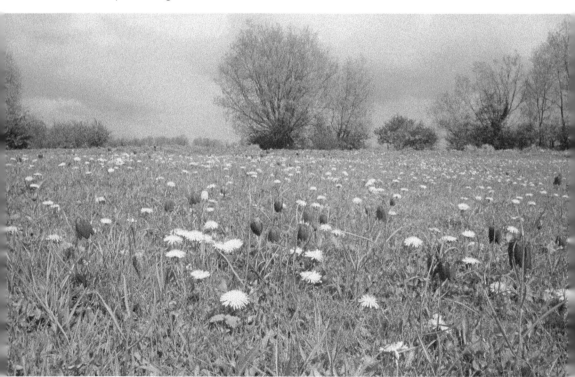

North Meadow National Nature Reserve. (Author's collection)

27. North Wessex Downs AONB

The North Wessex Downs Area of Outstanding Natural Beauty is located across the counties of Berkshire, Hampshire, Oxfordshire and Wiltshire and covers a staggering 670 square miles. Part of the Southern England Chalk Formation, which runs from Dorset to Kent, the area is a Site of Special Scientific Interest for a variety of reasons, with the chalk downs and dry valleys providing the perfect sites for a number of Neolithic and Bronze Age locations. One such area that is steeped in history, and yet might be easy to just walk by, is that of Oliver's Castle. Originally an Iron Age hill fort, it is also sometimes known as Bromham Hill Fort due to parish it lies in on the outskirts of Devizes, and it played an important part in the First English Civil War. The earthwork structure is defended by a single bank and ditch enclosing an area of around 4 acres, sits at the west end of the Vale of Pewsey and has stunning views across the flat plain stretching westwards from Devizes – no doubt the reason it was chosen. In 1643, Sir William Waller's Parliamentarian force was besieging Devizes, and his 2,500 cavalry camped here for three nights. On 13 July 1643, the Battle

Yellow fields of the North Wessex Downs. (Courtesy of Angel Ganev CC BY 2.0)

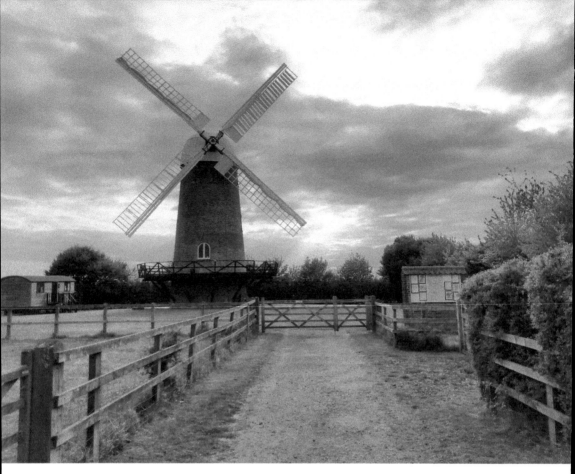

Above: Looking across the Vale of Pewsey at Wilton Windmill. (Courtesy of Michael Tyler CC BY-SA 2.0)

Below: Oliver's Castle, near Devizes. (Courtesy of Sarah J. Dow CC BY-ND 2.0)

of Roundway Down was fought, with a Royalist cavalry force under Lord Wilmot winning a crushing victory over Waller's men – many fell down the steep slopes of Oliver's Castle before being killed. Although it is named Oliver's Castle it is not thought that Oliver Cromwell ever went there. There are a number of major racing stables in the area, mainly because of the incredibly good quality turf here due to the chalk underlay. Many villages have strong horseracing connections, with the upland areas being used for gallops and training areas. I've heard a wonderful anecdote that the term 'steeplechase' originated in this area as a race between two villages, navigated by reference to the church steeples visible across the rolling downs. I do so hope it is true! The grass, woodlands and meadows are centuries old and help to make this part of Wiltshire simply beautiful.

28. Old Sarum

Old Sarum is the site of one of the earliest settlements in the country, let alone Wiltshire, and easily makes this collection of gems for a number of reasons. With the significant monoliths of Stonehenge and Avebury nearby it is thought that a Neolithic settlement on the hilltop may have been present here from possibly 3000 BC. However, there is evidence of a protective hill fort being built here during the Iron Age in around 400 BC with gigantic banks and ditches surrounding the hill, measuring 400 metres in length and 360 metres in width. With a double defensive bank, the site was occupied during the Roman period, but interestingly, archaeologists do not think it was used by the Roman army. It is known that Cynric, King of Wessex, captured the hill in AD 552, and centuries later, in 960, King Edgar assembled a national council at Old Sarum to plan a defence against the Danes. It was later abandoned and ransacked by the Danes in AD 1003. The defensive properties of the site were again recognised by the Normans, and four years after the conquest of 1066, a motte-and-bailey castle was built, and it is these earthworks and designs that remain so prevalent today. Held by the Norman kings themselves, Herman was installed as the first bishop of Salisbury and together with Osmund, who was a cousin of William the Conqueror, they started the construction of the first Salisbury Cathedral. In fact, Osmund, with all of his connections, was a very powerful man, and as Lord Chancellor of England he was responsible for the codification of the Sarum Rite and the compilation of the Domesday Book, which was probably presented to William I at Old Sarum in 1086. Although Sarum began to fall into disrepair in the centuries that followed, a bigger town developed, with homes building up beside the ditch that protected the inner bailey and Norman castle and kilns and furnaces being constructed. It is said that Henry II held his wife, Eleanor of Aquitaine, prisoner at Old Sarum in the 1190s, the open plain between Old Sarum and Wilton was one of only five specially designated by Richard I for the holding of English tournaments – one can only imagine the sights and sounds from these! It is during these times that it was decided to relocate the cathedral, built within the castle walls, to a new location due to issues with strong winds, insufficient

housing and that the soldiers of the royal fortress restricted access to the cathedral precinct. So, on Easter Monday 1219, a wooden chapel dedicated to the Virgin Mary was begun near the banks of the Hampshire Avon – the location of today's Salisbury Cathedral. The old cathedral was formally dissolved in 1226 and the inhabitants of the new city that was springing up around the new cathedral gradually took at the stone, wood and metalwork for building the 'new' Salisbury Cathedral and other buildings. The old settlement at Old Sarum became increasingly abandoned and Edward II ordered the castle's demolition in 1322. The castle grounds remained the property of the Crown before being sold by Henry VIII in 1514. Interestingly, the 'borough' of Old Sarum elected two members to the House of Commons despite the fact that it had no resident voters at all – in 1831, Old Sarum had eleven voters, all of whom were landowners who lived elsewhere. Old Sarum was known as a 'rotten borough', but this was eventually sorted by the 1832 Reform Act. This incredible history means that the castle and cathedral are considered very important British monuments, and they were among the twenty-six English locations scheduled by the 1882 Ancient Monuments Protection Act. These Grade I listed buildings are now maintained by English Heritage. Old Sarum also boasts an airfield that was selected in 1917 to provide facilities for a training station for the new Royal Flying Corps – the precursor to the RAF. After the First World War the airfield was kept open, and in the mid-1930s Old Sarum Airfield was identified as being suitable for becoming a permanent station. The site expanded from 19 acres to over 50 acres, with a whole range of new buildings. During the Second World War Old Sarum was one of the many countless bases that helped defend Britain from the skies, and certainly played its part in D-Day as thousands of ground personnel and virtually all RAF motor transport vehicles destined for Normandy passed through Old Sarum. After the war, the airfield was used by the military until 1979 and then used by a range of private companies and flying clubs, before closing in 2019.

An aerial view of Old Sarum Castle, with the foundations of the cathedral clearly visible. (Public Domain)

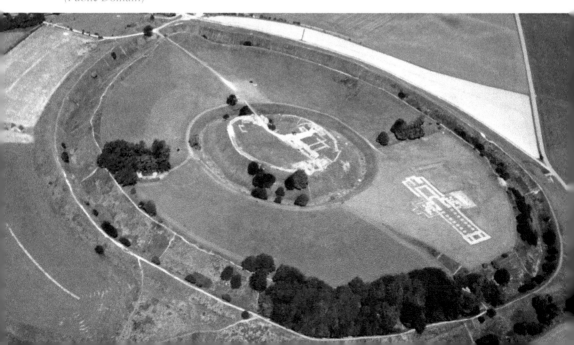

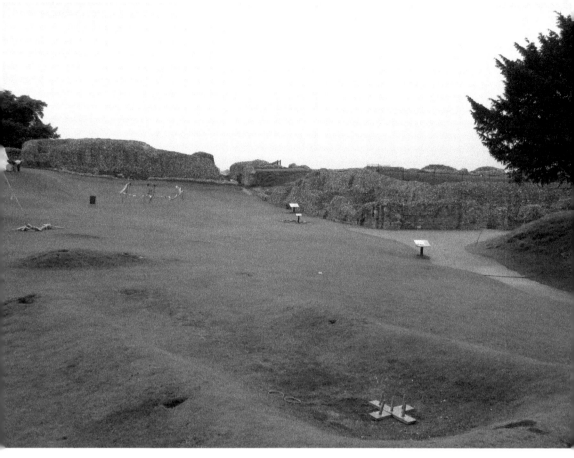

Above: The ruins of the castle walls on the Norman period central motte. (Author's collection)

Below: The exposed foundations of the cathedral. (Author's collection)

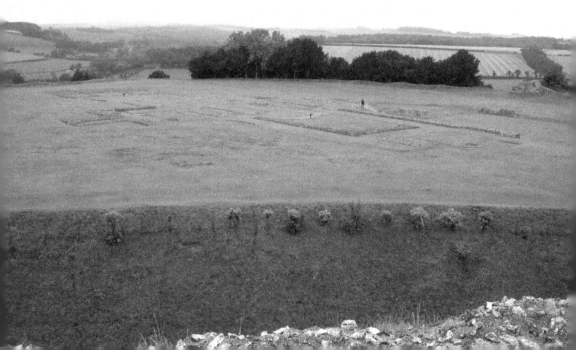

29. Old Wardour Castle

The ruins of the fourteenth-century Wardour Castle around 15 miles west of Salisbury are one of the most impressive sights in the county. Its story begins in 1385, when Baron John Lovell acquired the land, and in 1392 Richard II granted him permission to build a castle there. Wardour's six-sided design is unique in Britain and it is clearly inspired by the hexagonal castles that were in fashion at the time in parts of the Continent, especially France. The castle had a number of self-contained guest suites and all the usual rooms you'd expect to find in a castle. The Lovell family supported the Lancastrian cause during the Wars of the Roses, and as a result the castle was confiscated in 1461 by the state and passed through several owners until bought by Sir Thomas Arundell of Lanherne in 1544. This ancient prominent Cornish family owned much land in Cornwall and held several estates in Wiltshire. However, just eight years later, in 1552, Sir Thomas was executed for treason and the castle was again confiscated. In 1570, it was bought back by his son, Sir Matthew Arundell, and life returned to normal for the next seventy years. At this point, the 1st Baron Arundell of Wardour, Thomas Arundell, was a very active Catholic landowner and with the onset of the first English Civil War they naturally sided with the Royalists. During that war the 2nd Baron Arundell of Wardour, also called Thomas, was away on the king's business, leaving a garrison of twenty-five trained fighting men to defend the castle and his wife, Lady Blanche Arundell. On 2 May 1643, Sir Edward Hungerford arrived with a Parliamentarian Army of approximately 1,300 men. With those inside refusing point blank to allow them in to search for Royalist sympathisers, Hungerford laid siege to the castle, using guns and mines on its walls. After holding out for five days, Lady Arundell agreed to surrender, with the castle being placed under the command of Colonel Edmund Ludlow. Lord Arundell died of his wounds after the Battle of Stratton that same month, so the son of Thomas and Blanche – Henry, 3rd Lord of Arundell – brought a Royalist force to reclaim the castle. But this did not go exactly to plan. By November 1643 he had blockaded Wardour, but the excessive mining of the walls meant that most of the castle was blown up. The Parliamentary garrison did then surrender in March 1644, which was what he wanted, but sadly he had very little castle left to reclaim. In the coming centuries the family slowly recovered some of their power, but it wasn't until the 8th Baron that they were able to finance rebuilding. The result was New Wardour Castle, which was much more of a symmetrical stately home than a castle, and the ruined shell of Wardour Old Castle remained as an ornamental feature. Today, the ruins are very evocative. Above the front entrance is the Arundell coat of arms and a description of the Arundell's possession of Wardour, which was erected by Sir Matthew Arundell in 1578 to celebrate his recovery of the property. On the ground floor you can get a sense of some of the rooms that were once there, with the stairs that once led up to the great hall. Very little remains of the upper rooms, which once would have been the most inviting part of the castle. Like the great hall, they would have been high rooms with an intricate wooden roof. It is still possible to view the surrounding

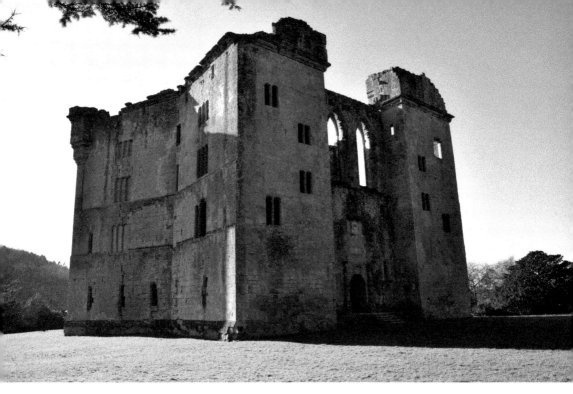

Above: The fourteenth-century Old Wardour Castle. (Courtesy of Hugh Llewelyn CC BY-SA 2.0)

Below: The rear of the castle is in a more ruinous state. (Courtesy of glenn Bowman CC BY-SA 2.0)

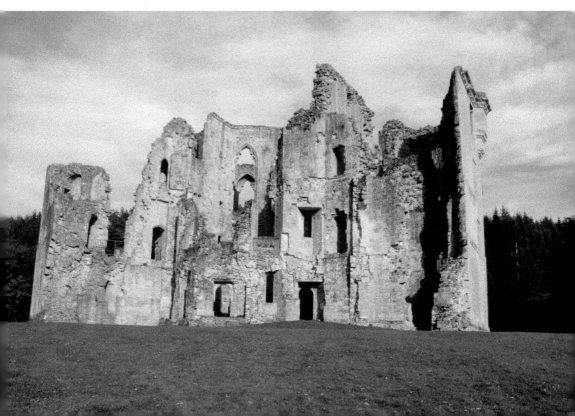

A view of the lake that was built for New Wardour Castle. (Courtesy of Hugh Llewelyn CC BY-SA 2.0)

woodland estate from the top and this gives you an idea of the power this castle and family once had. It is not surprising to find out that a site like this has been used in a number of films, most notably the 1991 Kevin Costner feature *Robin Hood: Prince of Thieves*, and a visit here won't leave you disappointed.

30. Pepperbox Hill

Pepperbox Hill is also known as Eyre's Folly due to the fact that the tower was built in 1606 by Giles Eyre of Brickworth House. The original purpose of the tower isn't completely clear, but one theory suggests that it was built as a hunting stand – somewhere the local landowners' wives (including Eyre's wife, Jane) could watch the local hunt in comfort without being exposed to public gaze or the weather.

Eyre's Folly on Pepperbox Hill. (Courtesy of Peter Hurford CC BY 2.0)

The hexagonal three-storey tower was likely rebuilt around 1900 due to wear and tear, and was topped by a weathervane. The building is unusual as it has one doorway per face and one window per face on both the first and second floors; however, these are all now bricked up and there is no evidence to suggest when this happened or by whom. The structure got the name 'the Pepperbox' because of the it's resemblance to a pepper pot or pepper box, and it sits at the highest point on 'Pepperbox Hill', with far-reaching views and overlooking the village of Alderbury. It is thought that in the early eighteenth century the Pepperbox may have been used by highwaymen, who would attack any carriages as they reached the summit of Pepperbox Hill, with the people and horses worn out by their climb up the hill. During the Second World War, the tower was used by the Home Guard as a lookout post, and today this Grade II listed building is looked after and maintained by the National Trust.

31. REME Museum of Technology

The REME Museum of Technology is a fascinating place and helps to preserve the history and heritage of the Corps of the Royal Electrical and Mechanical Engineers – after whom the museum is named. They were originally formed in 1942 during the Second World War, as a way of keeping all aspects of the army, both tactical and logistical, moving forward in all conditions. The Royal Electrical and Mechanical

The REME Museum of Technology has a whole range of vehicles on display. (Courtesy of Jamie Franklin CC BY-ND 2.0)

Engineers are responsible for the maintenance, servicing and inspection of electrical and mechanical equipment used by the British Army. As Montgomery of El-Alamein put it, the REME exists 'to keep the punch in the Army's fist'. The museum began its life in 1958 in Arborfield, Berkshire, where it was originally located in just two rooms of Moat House – the former commander's accommodation of the Arborfield Army Remount Service Depot. However, by the very nature of the associated history of the REME, the museum expanded and they moved to a nearby building that allowed significantly more artefacts, objects and vehicles to be put on display. However, as part of the Defence Technical Training Change Programme, in April 2015 the museum closed its doors in preparation for a relocation from Berkshire to MoD Lyneham in Wiltshire, around 10 miles from Swindon. A former officers' mess at MOD Lyneham was restructured to provide a new home for the museum, and in the process they redesigned the displays, added in more artefacts and made the public facilities much better. With a shop, large café, an education suite with museum-led workshops available to schools and families, as well as conferencing facilities and a reading room for researchers. The museum opened its new doors to the public in June 2017 and has over 100,000 items within its displays and archives. It contains vehicles, uniforms, weapons and medals, as well as photographs and paperwork.

What is especially pleasing is the way in which children are catered for, with activity packs and quizzes complimenting the tanks, vehicles and weapons on display. A museum that preserves and tells the story of this historic branch of the army, this really is an enjoyable visit.

32. Royal Wootton Bassett

A charter from Malmesbury Abbey in AD 681 refers to a holding called Wodeton, and this is usually taken as the starting point for recorded history of Wootton Bassett. Mentioned in the Domesday Book with 'land for 12 ploughs, a mill, 24 acres of

Royal Wootton Bassett's former Town Hall is now the local museum. (Courtesy of Amanda Slater CC BY-SA 2.0)

meadow and 33 acres of pasture and woodland'. This small market town has a most notable building standing in its town centre. Now the Wootton Bassett Museum, this upper-storey structure, supported by fifteen pillars, is the former town hall and was built at the end of the seventeenth century as a gift from the Hyde family. Of course, the town received notoriety in the early twenty-first century, when from April 2007 the bodies of servicemen and women of the British Armed Forces killed in Iraq and Afghanistan were repatriated to nearby RAF Lyneham, before passing through the town on their way to Oxford. Hearing of this, local members of the Royal British Legion began to formally show their respect to the soldiers as they passed through their town, which led to other people assembling along the route, sometimes with over 1,000 people lining the streets, attracting significant media coverage. When RAF Lyneham closed in September 2011 the repatriations moved to RAF Brize Norton, but prior to this, in March 2011 Prime Minister David Cameron announced that while 'from September, military repatriations will no longer pass through the town of Wootton Bassett, Her Majesty has agreed to confer the title "Royal" upon the town, as an enduring symbol of the nation's admiration and gratitude'. So, from 16 October 2011, Royal Wootton Bassett became the first town to receive this status in over 100 years.

33. Salisbury

The cathedral city of Salisbury has to be one of the most picturesque in the country. Situated in the south-east of Wiltshire, it is one of the few places that can trace its beginnings to almost the exact day. Nearby Old Sarum was the location of a significant castle and the site of a cathedral, but in the early thirteenth century it was decided to relocate the cathedral to nearby plains. On Easter Monday 1219, a wooden chapel dedicated to the Virgin Mary was begun near the banks of the Hampshire Avon – the location of today's Salisbury Cathedral. With the old cathedral being formally dissolved in 1226, the inhabitants of the new city that was springing up around the new cathedral gradually took at the stone, wood and metalwork for building the 'new' Salisbury Cathedral and other buildings of 'New Sarum'. New Sarum was made a city by a charter from Henry III in 1227 and by the fourteenth century it was the largest settlement in Wiltshire. The city wall surrounds 'The Close' and it has five gates – the composer Handel is said to have stayed in a room above St Ann's Gate. It is a city of history. Edward I met Robert the Bruce and others at Salisbury in October 1289, resulting in the Treaty of Salisbury, and during the Great Plague of London Charles II held court in Salisbury's cathedral close. The city was chosen to assemble James II's forces to resist the Glorious Revolution and it is said that he arrived with approximately 19000 men on 19 November 1688. However, only a few days later, on 26 November, James returned to the safety of London as he was unable to trust his own commanders. John Constable made a number of landscape paintings featuring the cathedral's spire and the surrounding

Above: Salisbury has a charming town centre. (Courtesy of Steven Penton CC BY 2.0)

Below: The River Avon flows peacefully through the town. (Courtesy of Kai Hendry CC BY 2.0)

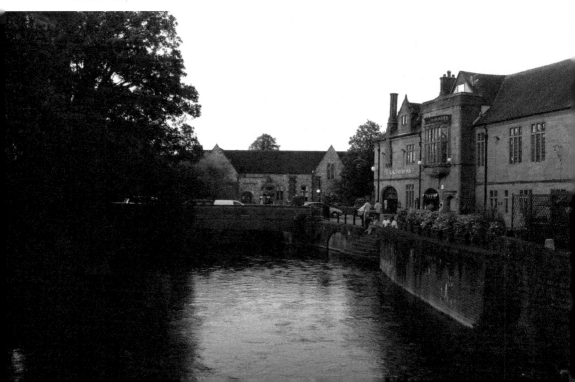

countryside here. The name of the city was finally formally amended from 'New Sarum' to 'Salisbury' during the 2009 changes of the 1992 Local Government Act. The rivers that flow through the city have obviously been redirected and landscaped over the years, making for some beautiful walks, such as the Town Path, while also feeding into public gardens, such as Queen Elizabeth Gardens. As well as holding an annual St George's Day pageant, the Salisbury Museum is housed in the King's House, opposite the west front of the cathedral. The Grade I listed building was constructed in the thirteenth century and holds a permanent Stonehenge exhibition gallery, with interactive displays about Stonehenge, which of course only lies a few miles away. It has the Pitt Rivers display and a costume gallery, showcasing textiles from the area, which allows you to dress up as characters from Salisbury's past. Another museum of note is the one at Arundells, in Cathedral Close, which was the home of former Prime Minister Sir Edward Heath. Built in the thirteenth century, this Grade II listed building includes political memorabilia from Heath's life, such as his ministerial boxes, personal banner from the Order of the Garter and a desk in his study that originally belonged to an earlier prime minister, David Lloyd George.

34. Salisbury Cathedral

Salisbury Cathedral can surely lay claim to being one of the most stunning buildings in the country. This view, inside or out, never gets old, and neither does the beauty of the cathedral. It is regarded by many as one of the leading examples of Early English architecture, thanks to the fact that its main body was completed in just thirty-eight years, from 1220 to 1258, providing the whole building with a consistent architectural style. A total of 70,000 tons of stone, 3,000 tons of timber and 450 tons of lead were used in its construction. Nearby Old Sarum was the site of the original cathedral, but in the early thirteenth century it was decided to relocate the cathedral to nearby plains due to issues with strong winds, insufficient housing and the soldiers of the royal fortress restricting access to the cathedral precinct. On Easter Monday 1219, a wooden chapel dedicated to the Virgin Mary was begun near the banks of the Hampshire Avon – the location of today's Salisbury Cathedral. It has the largest cloister and the largest cathedral close in Britain at 80 acres. The cathedral is of course perhaps best known for its huge spire, which reaches up to 123 metres, making it the tallest church in the United Kingdom; it has dominated the skyline since 1320. Visitors can take the 'Tower Tour', in which the interior of the hollow spire, with its ancient wooden scaffolding, can be viewed, along with the nave – from the Western Triforium Gallery, 60 feet above the floor. The cathedral also has a couple of other treasures. The Salisbury Cathedral clock, which dates from around AD 1386, is apparently the oldest working modern clock in the world. It has no face as all clocks of that date rang out the hours on a bell. According to records it was originally located in a bell tower that was demolished in 1792 and then moved to the cathedral tower, where it remained until 1884. It was then placed into storage and totally forgotten about, until it was discovered in an attic of the cathedral in

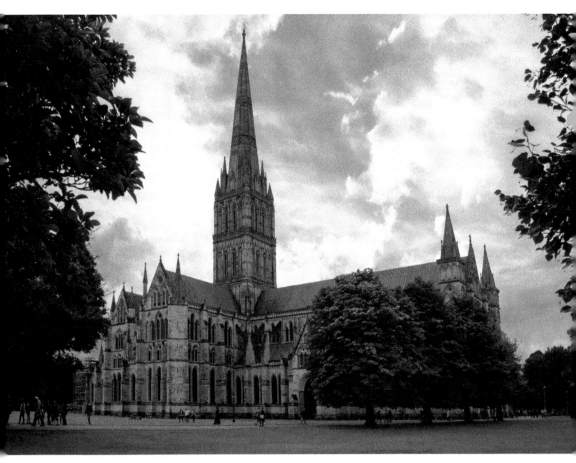

Above: Salisbury Cathedral
has the tallest church spire in
the UK. (Courtesy of Alison
Day CC BY-ND 2.0)

Right: The inside of the
cathedral is simply stunning.
(Courtesy of Jack Pease
Photography CC BY 2.0)

Above: The cathedral seen 60 feet above the floor from the Western Triforium Gallery. (Courtesy of Jack Pease Photography CC BY 2.0)

Below: Salisbury Cathedral dominates the town's skyline. (Courtesy of Pedro Szekely CC BY-SA 2.0)

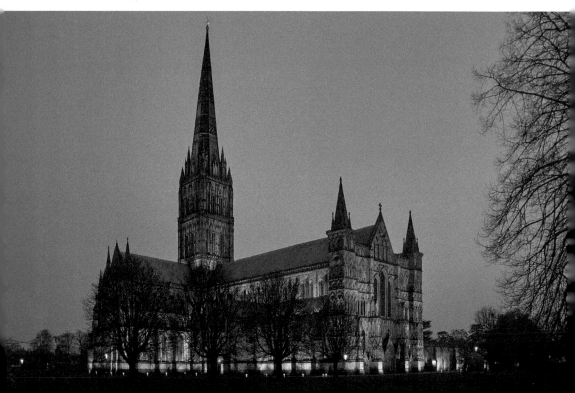

1928. On top of this, the chapter house of the cathedral displays the best-preserved of the four surviving original copies of Magna Carta – a charter of liberty and political rights that were obtained from King John of England by his rebellious barons at Runnymede in 1215. Elias of Dereham, who was present at Runnymede and was tasked with distributing some of the original copies, later became a canon of Salisbury and supervised the construction of the cathedral, which is how this historic document got here. Despite a few fires in its lifetime, Salisbury Cathedral is the fifth tallest medieval building in the world. Free to enter, it is still a working religious building that oozes history and beauty at every turn.

35. Shearwater Lake

Located near the town of Warminster, Shearwater Lake is a man-made freshwater lake that is formed from a tributary of the River Wylye. One of five lakes within the Longleat estate, it was created at the end of the eighteenth century by the 3rd Duke of Bridgwater, Francis Egerton. The lake is surrounded by mature woodland and is

A view of Shearwater Lake. (Author's collection)

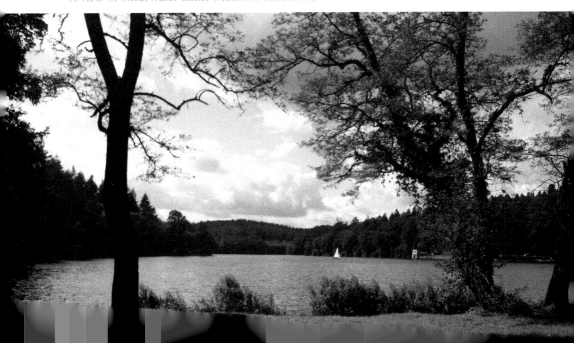

popular with anglers, walkers, swimmers, and cyclists. In fact, it is a haven for fishing and sailing. The established open woodland allows you to get close to nature, where there are some magnificent beech trees and conifers growing. The open fields and green lanes offer a wealth of wild flowers, butterflies and birds for you to discover, along with all sorts of other wildlife. This is an easy place to come and get away from it all.

36. Silbury Hill

The prehistoric artificial chalk mound at Silbury Hill is splendid in its simplicity. It is part of the Stonehenge, Avebury and Associated Sites UNESCO World Heritage Site and, standing at just under 40 metres in height, is the tallest prehistoric man-made mound in Europe. The site itself covers 5 acres and archaeologists believe it was constructed in several stages between 2400 and 2300 BC, making this a 4,000-year-old structure. The base of the hill is circular and over 160 metres in diameter, while the

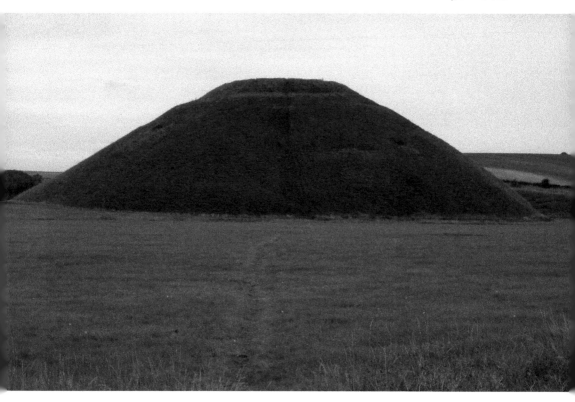

Silbury Hill is the tallest prehistoric man-made mound in Europe. (Author's collection)

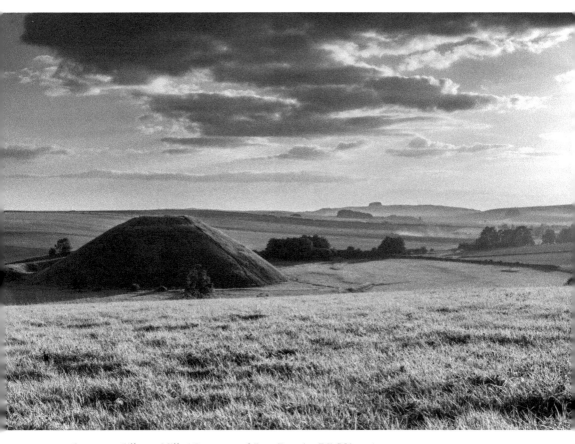

Sunset at Silbury Hill. (Courtesy of Ben Cremin CC BY 2.0)

summit of Silbury Hill is flat-topped and around 30 metres in diameter. It is thought that a smaller mound was constructed first and then enlarged later and that the top originally had a rounded profile, but that this may have been flattened in the medieval period to provide a base for a building or perhaps with a defensive purpose in mind. There have been many excavations of the mound, the first recorded of which was by seventeenth-century antiquarian John Aubrey, whose *Monumenta Britannica* were published between 1680 and 1682. Later on, William Stukeley wrote in 1723 that a skeleton had been discovered during tree planting on the summit. In 1776, the Duke of Northumberland and Colonel Edward Drax sank a vertical shaft from the top, and in 1849 a tunnel was dug horizontally from the edge into the centre. In 1968 to 1970, Professor Richard J. C. Atkinson undertook work at Silbury that was broadcast on the BBC. He dug a number of trenches at the site, as well as reopening the 1849 tunnel, finding the remains of winged ants, which indicate that Silbury was begun in August. In May 2002, a collapse of the 1776 excavation shaft made a hole appear at the top of the hill, allowing English Heritage to opportunistically take new surveys and dig new trenches while repairing the damage. They discovered an antler fragment, which came back with a radiocarbon date of circa 2490–2340 BC, which dates the second phase

of the mound to the Late Neolithic period. Since then, recent work on the surrounding ditch has discussed the fact it may not have been just a source of chalk for the hill, but actually a purpose-built moat. In March 2007, English Heritage announced that there was once a Roman village found at the foot of Silbury Hill, being the size of around twenty-four football pitches. According to legend, Silbury Hill is the last resting place of a King Sil, but its actual purpose is unknown. In his book, John C. Barret discussed the fact that any ritual at Silbury Hill would have involved physically raising certain individuals above the level of everyone else, and that those few individuals, in a privileged position, would have been visible for miles around and at several other monuments in the area, possibly indicating an elite group powerfully displaying their authority. Whatever its purpose, Silbury Hill is a thought-provoking place. Built at a time when even just surviving was difficult, this was deemed important enough to spend countless man hours on and has lasted ever since.

37. Steam – Museum of the Great Western Railway

Housed in a restored Grade II listed railway building, STEAM – Museum of the Great Western Railway is a fantastic day out for people of all ages. The building was part of one of the largest railway works in the world: the old Swindon Works of the Great

A view of the STEAM Museum of the Great Western Railway. (Author's collection)

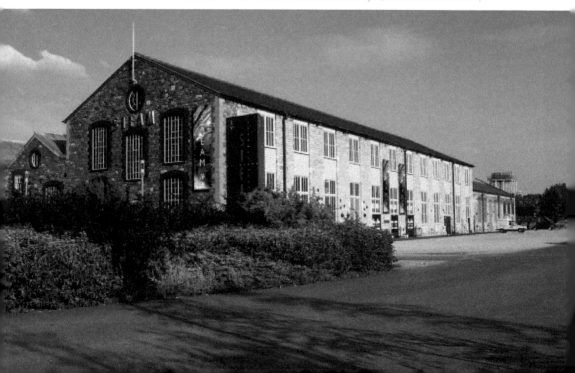

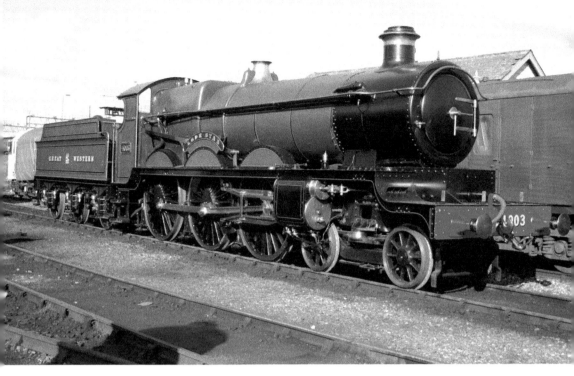

A Great Western Railway 'Star' is one of many trains on display. (Courtesy of Hugh Llewelyn CC BY-SA 2.0)

Western Railway, which operated for over one hundred years from 1843 to 1986. The museum opened in the year 2000 and replaced the former GWR Museum, which had five locomotives on display. The STEAM museum has a much larger collection of locomotives on display, as well as a range of exhibits, from static to more lifelike collections, with hands-on exhibits and interactive displays. The museum also tells the history of the Great Western Railway and the life of Isambard Kingdom Brunel, the famous Victorian engineer who masterminded the Great Western Railway. Many of the staff are ex-railway workers who are always keen to speak to visitors and help them get a better understanding of just how important the railways were, aided by the fabulous reconstructions within the museum.

38. Stonehenge

Everyone recognises Stonehenge. It is one of the true wonders of the world and a gem of Wiltshire that has mystified and amazed in equal amounts for thousands of years. Stonehenge is one of the most famous landmarks in the whole of the United Kingdom and is often regarded as a British cultural icon. Part of the Stonehenge,

Avebury and Associated Sites UNESCO World Heritage Site, it has been a legally protected Scheduled Ancient Monument since 1882 and is unique in that it is owned by the Crown and managed by English Heritage with the surrounding land owned by the National Trust. What is there to write about this awe-inspiring place that hasn't been done so already? Visible for miles around on the flat plains on which it lies, Stonehenge is an iconic prehistoric monument that is near the A303 at Amesbury. Archaeologists believe the ring of standing stones were constructed between 3000 BC and 2000 BC in the middle of the most dense complex of Neolithic and Bronze Age monuments in England. The stones are simply staggering, each around 4 metres high, 2 metres wide, and weigh around 25 tons. There have been deposits containing human bone date that date from as early as 3000 BC – the same time period from when the ditch and bank were first dug, and many believe that the site could have been a burial ground from its earliest beginnings. It is thought that the site of Stonehenge we see now, evolved in several construction phases that spanned around 1,500 years. Archaeologists have found evidence of large-scale construction on and around the monument that perhaps even extends the landscape's time frame to 6,500 years. The first phase of the monument, dated at 3100 BC, was a circular bank and ditch enclosure made of chalk, measuring about 110 metres in diameter, standing in open grassland. It is thought that soon after this, in the early third millennium BC, a timber structure was built within the enclosure due to a number of postholes dating to this time. Following this, in 2600 BC the third stage of Stonehenge's evolution saw builders abandon timber building in favour of stone and they dug two arrays of holes in the centre of the site. These holes held up to eighty standing stones and it is generally accepted that these 'bluestones' were transported by the builders from the Preseli Hills, an incredible 150 miles away in modern-day Pembrokeshire, Wales – a staggering achievement considering the lack of infrastructure at the time. It is then thought that between 2600 BC and 2400 BC thirty enormous sarsen stones were erected as a 33-metre-diameter circle of standing stones, with a ring of thirty stones resting on top of them. These now iconic stones were fitted to one another using a tongue-and-groove joint. It seems they had been worked with the final visual effect in mind, with the inner faces of some of the stones being a lot smoother than the outer faces. Later in the Bronze Age, over the next 200 years, the bluestones appear to have been re-erected and placed within the outer sarsen circle. Between 2280 BC and 1930 BC the bluestones were rearranged again: placed in a circle between the two rings of sarsen stones and in an oval at the centre of the inner ring. This incredible structure was created by a culture that had no written records; it is only through amazing archaeology that we have these ideas as to how it was built. It seems likely that the last usage of the site was probably during the Iron Age, and although Roman coins and medieval artefacts have all been found around the monument no one can say for sure if it was in continuous use. Of course, the subject of great debate, is what purpose Stonehenge served. The site is aligned to the sunset of the winter solstice and the opposing sunrise of the summer solstice, and the majority of historians and archaeologists agree that is was likely used as an astronomical observatory or as a religious site – the number of bones and burials in the area seem to suggest so, although it is also possible that Stonehenge might have been a place for healing. It is interesting to know that Stonehenge has changed ownership several times since Henry VIII acquired Amesbury Abbey and its surrounding lands. He gave it to the Earl of Hertford in 1540, who subsequently passed it to Lord Carleton, the

Marquess of Queensberry and then Antrobus family of Cheshire in 1824. During the First World War an aerodrome was built just to the west of the circle, but the site was sold soon after in 1915 by the Antrobus family after their last heir was killed in the fighting in France. Sir Cecil Herbert Edward Chubb became the last private owner of Stonehenge, but he soon donated it to the British government in 1918. Over the years there have been some major restorations to the monument – most involving the straightening and concrete setting of stones that were in danger of falling over. A 2013 survey excavated more than 50,000 cremated bone fragments, from sixty-three individuals, that were buried at Stonehenge. When Stonehenge was first opened to the public you were able to walk and even climb on the stones, but they were roped off in 1977 as a result of serious erosion, although it is possible to book tours that take you inside. Today, the visitor centre allows thousands of visitors the opportunity to come and marvel at these stones. Whatever its true purpose, it cannot be denied that Stonehenge is one of the most iconic structures in the country.

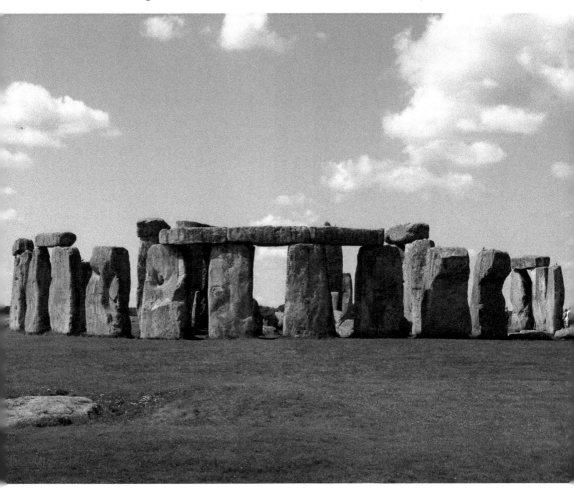

One of the most iconic places in the world – Stonehenge. (Courtesy of Gareth Wiscombe CC BY 2.0)

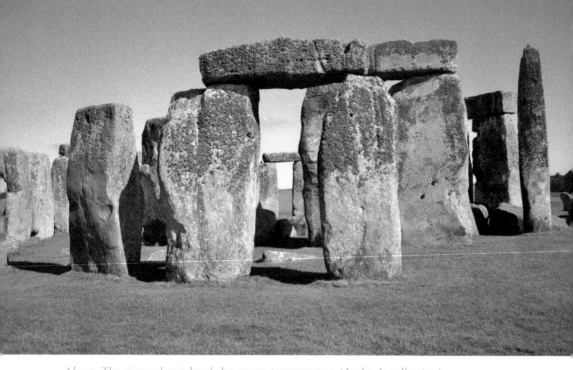

Above: The size and weight of the stones is staggering. (Author's collection)

Below: The standing stones dominate the landscape for miles around. (Courtesy of Andy Powell CC BY 2.0)

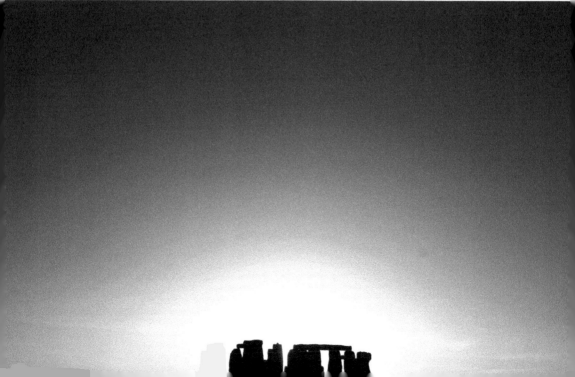

39. Stourhead

The 2,650-acre Stourhead estate is one of the most delightful places to visit. Located at the source of the River Stour, the estate begins in Wiltshire and actually extends into Somerset. The estate consists of a Grade I listed eighteenth-century Palladian mansion, the entire village of Stourton, formal gardens, farmland, woodland, and for the last seventy years has been part-owned by the National Trust. The Stourton family had lived at the Stourhead estate for 500 years until they sold it to Sir Thomas Meres in 1714, who in turn sold it in 1717, this time to Henry Hoare, son of wealthy banker Sir Richard Hoare. At this point, the original manor house was demolished so this wealthy family built a Palladian mansion between 1721 and 1725. Many

The bridge and the Temple of Flora at Stourhead. (Courtesy of Roger Ward CC BY 2.0)

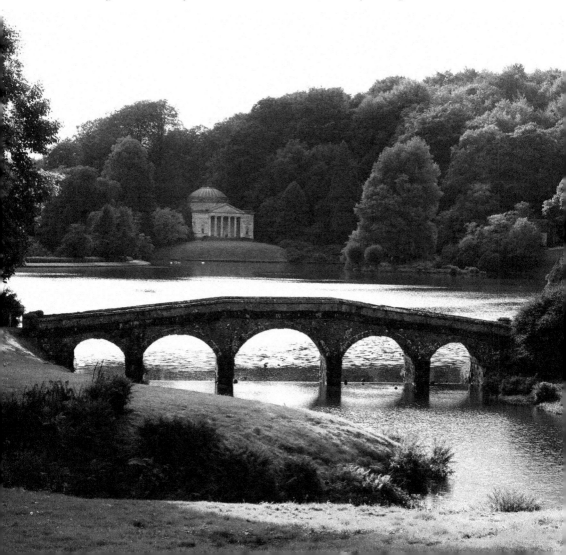

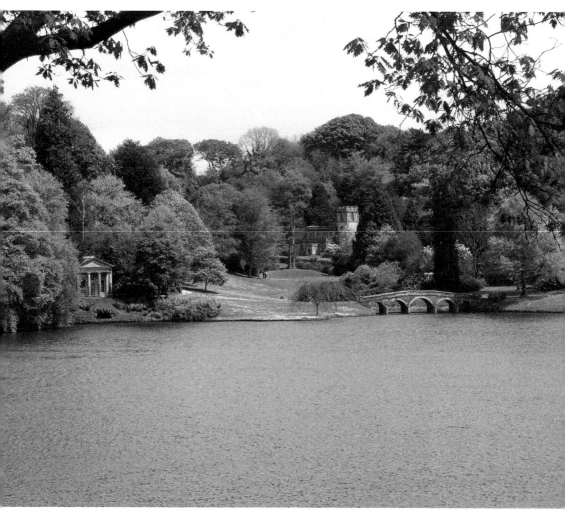

The beautiful view across Stourhead lake towards the church. (Author's collection)

changes and additions were made to the house and grounds over time. The Temple of Ceres was added in 1744, the Temple of Hercules in 1754 and the Temple of Apollo in 1765, before the 50-metre Alfred's Tower was built in 1772. Cottages, lodges, landscaped gardens and an artificial lake were added to the grounds, along with two of the estate's most noticeable buildings – the five-arched Palladian bridge and Pantheon. These two structures compliment each other and visually 'frame' each other. The house was gutted by fire in 1902, but many of the family heirlooms were saved and the house was simply rebuilt in an identical style. The last Hoare family member to own the property, Sir Henry Hugh Arthur Hoare, gave the house and gardens to the National Trust in 1946. Open to the public, the whole estate is a delight to visit – the grandeur of the house, the beautiful natural space of the gardens and parkland, and the hidden treasures around every corner.

40. Summer Solstice Festival

The summer solstice, which is also known as midsummer, occurs when one of the Earth's poles has its maximum tilt towards the Sun. This is when the Sun reaches its highest position in the sky and is the day with the longest period of daylight – usually occurring sometime between 18 and 25 June. It is known that since prehistory this moment has been seen as a significant time of year in many cultures and has been widely marked by festivals and rituals. This continues to this day, and although there are many sacred sites to celebrate the summer solstice, in Wiltshire there is one place above all others – Stonehenge. Stonehenge is a monument that aligns to the midsummer sunrise as well as the midwinter sunset – incredible when you

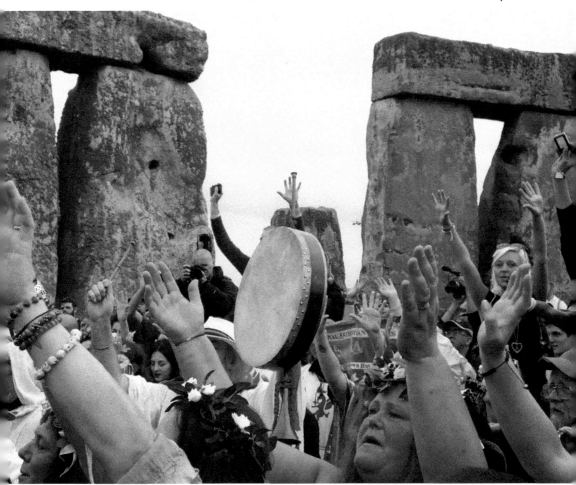

The summer solstice celebrations at Stonehenge. (Courtesy of Jamie Franklin CC BY 2.0)

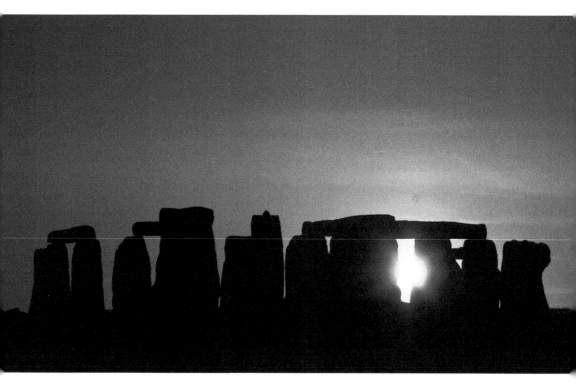

Stonehenge on the solstice. (Courtesy of Andy Powell CC BY 2.0)

remember this was built over 4,000 years ago. Thousands choose to gather at the monument as the ultimate place to make midsummer. There is always a lovely, friendly atmosphere, often with a cheer greeting the rising sun, followed by music, song and a general feel-good vibe. At summer solstice someone standing within the stone circle looking north-east through the entrance, would see the Sun rise in the approximate direction of the heel stone, the ancient entrance to the stone circle, with rays of sunlight channelled into the very centre of the monument – often making for a stunning photograph. This is a tradition that goes back thousands of years at one of the world's most sacred sites.

41. Tisbury

The large village of Tisbury finds itself nestled in the Vale of Wardour on the West Wiltshire Downs Area of Outstanding Natural Beauty. Incredibly, there is evidence of early human activity in the area, with the discovery of skull fragments of a young woman being found. In 2011, there was significant evidence of a Bronze Age

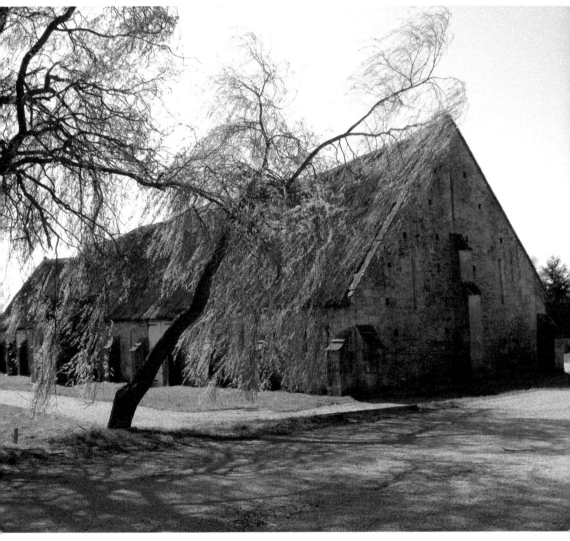

A thatched fifteenth-century tithe barn at Tisbury. (Courtesy of Jim Linwood CC BY 2.0)

settlement being here too, with the excavation of the Tisbury Hoard. Containing 114 items from the ninth to eighth century BC, there are a range of tools (axe heads, chisels, sickles and gouges) and weapons (spearheads, daggers, knives, swords and scabbard fittings). To the south-east of the village there are the remnants of a large hill fort, which is known as Castle Ditches. Within the earthwork ramparts of the hill fort is a long barrow measuring around 60 metres long, and it is thought that a stone circle once stood in one of the fields opposite. During Saxon times the settlement that was here came into the possession of Shaftesbury Abbey, who built a tithe barn at Abbey Grange Place, which is still standing today. A Grade I listed building, it is reported to have the largest thatched roof in England and is certainly worth a visit.

Zion Hill Chapel in Tisbury is now residential accommodation. (Courtesy of Jim Linwood CC BY 2.0)

The village saw much prosperity from the quarries in the nearby area that produced stone for the building of Salisbury Cathedral, and also from the wool that supported a local cloth industry. With Old Wardour Castle not too far away, Tisbury is a village that has grown well throughout the centuries. Peaceful and calm, it is not surprising that the village has a number of religious buildings, two of which are listed buildings. It is also interesting to note that Rudyard Kipling's parents bought a residence along Hindon Lane, which they renamed 'The Gables'. It is known that their famous son visited them here for weeks at a time to get away from any distractions and focus on his writing, and it is said that the novel *Kim* was written here.

42. Upavon

The small rural village of Upavon sits on the north edge of Salisbury Plain on the upper portion of the River Avon, which runs through the village. There is evidence of humans being at Uphaven all the way back in the Iron Age, with the settlements of Casterley Camp and Chisenbury Camp nearby. Upavon is mentioned in the Domesday Book and grew during the Middle Ages. Because of its location on the edge of Salisbury Plain, in 1912 the village became one of the first places to have an airfield constructed in what was the birth of the Royal Air Force. RAF Upavon was originally constructed as a Royal Flying Corps (RFC) base and became the RFC Central Flying School on 19 June 1912. It is here in 1913 that the first night landing was made in England, and between 1914 and 1915 two officers stationed here developed the bomb sight for planes, which was subsequently used at the Western Front in the First World War. During the Second World War, RAF Upavon's primary role was to train and supply flight instructors to the military flying schools and it is recorded that George VI visited the airfield during the Second World War. In 1993, the RAF officially handed over the site to the British Army and it became a British Army garrison called Trenchard Lines, which is still in use today. This small village remains just a stone's throw from Salisbury Plain, offering tranquillity and wilderness right on its doorstep.

The thatched houses of Upavon. (Courtesy of David Howard CC BY 2.0)

43. Wansdyke

Wansdyke is a series of defensive medieval earthworks that run for around 20 miles. Consisting of a ditch and an embankment (made from the spoil from the ditch) there are actually two main sections – an eastern dyke and western dyke – and between these two dykes there is a 14-mile middle section formed by the remains of the London to Bath Roman road, sometimes referred to as 'mid-Wansdyke'. The eastern dyke runs for approximately 9 miles between Savernake Forest and Morgan's Hill and is the more impressive of the two sections that still remain as it has been less disturbed by later agriculture and building. There are parts of the East Wansdyke that are just staggering, with the bank reaching up to around 4 metres high in some parts and the ditch dropping down nearly 3 metres. There is evidence of deliberate gaps (gates) being put into the earthwork wall, not just a military defence, but as a way to control the flow of locals and travellers. It is thought that this part of the earthwork was probably built after the withdrawal of the Romans, during the fifth or sixth century, but before the arrival of the Anglo-Saxons – and as the ditch is on the northern side of the earthwork, it seems likely that it was intended as a defence against the Saxons coming into the

Part of the Wansdyke ditch and earthwork. (Courtesy of Claire Cox CC BY-ND 2.0)

West Country from the Thames Valley. The western dyke runs for around 12 miles from Monkton Combe to the ancient hill fort of Maes Knoll in Somerset, with some suggesting that it even extended beyond this to the hill forts above the Avon Gorge. It follows the same structure as the east section but is sadly in a worse condition, with a 1,000-metre section at Odd Down being designated an Ancient Monument and appearing on the Heritage At Risk Register. What is clear is that this defensive ditch was built using some considerable man power in an effort to protect their lands. The fact it still remains, stretching for miles across the Wiltshire countryside, is a testament to the effort shown by those fifth- and sixth-century builders.

44. Warminster

The town of Warminster can trace its origins back to around the Iron Age, with the nearby hill forts of Battlesbury Camp, Scratchbury Camp and Cley Hill leaving their mark on the landscape, and with Roman villas in the area further showing

View of Warminster from Caen Hill. (Courtesy of Sarah Ward CC BY 2.0)

that humans have been settling here for a long time. While it is mentioned in the Domesday Book, it is in the Anglo-Saxon period that the town really developed, as it had a royal manor and an Anglo-Saxon minster. During the thirteenth century Warminster was given the right to hold a market, and by 1377 the town had 304 taxpayers – a large amount for the fourteenth century. Warminster, like most market and trade towns in the West Country, saw some incidents during the English Civil War of 1642–51. The town, who aligned themselves with the Parliamentarians, found themselves as the safe haven for Major Henry Wansey, who then became besieged in the town by the Royalists. A number of skirmishes ensued and by 1646 the town had suffered a lot of damage. In the coming centuries Warminster prospered because of its market, which saw significant wool, clothing, malting and corn trades being done. In fact, it is probably fair to say that the market was the economic mainstay for the town right up until the nineteenth century, and not just because of the trades. The town had developed a large amount of accommodation for visitors to the market, with over 100 rooms and approximately fifty inns and alehouses making a roaring trade. The British army's Waterloo Lines, home to a number of army specialist training schools, is stationed in Warminster, and the town is also headquarters for the Small Arms School Corps and Headquarters Infantry – formed in 1996 and responsible for the recruiting, manning and training policy of the onfantry.

45. West Kennet Long Barrow

The surprisingly large West Kennet Long Barrow, part of the Stonehenge, Avebury and Associated Sites UNESCO World Heritage Site, is yet another impressive prehistoric monument in Wiltshire. Archaeologists have established that it was built by communities shortly after the introduction of agriculture to Britain from Europe at some point in the thirty-seventh century BC. This chambered long barrow located on a crest of a hill near the village of Avebury, is built out of earth, local sarsen stones and limestone that has been imported from the Cotswolds. It sits on a mound that measures 100 metres in length and 20 metres in width, which was likely used for human activity before the barrow was built. The stone chamber itself has been called 'more elaborate' than most other examples as it extends for 12 metres inside the barrow and has a roof height of around 2 metres above the chamber floor. Human remains have been found inside the barrow, leading most to believe that this some sort of tomb, with the findings belonging to a mixture of men, women, children and adults. Archaeologists have conducted radiocarbon dating tests on bones retrieved from inside the long barrow, and they revealed that the oldest individuals within it had died around 3670–35 BC. There is also evidence that animal remains were placed here over a period of several centuries, along with various flint tools and ceramic items. During the third millennium BC it seems that large sarsen boulders and earth were erected across the forecourt,

blocking any further entrance to the chamber. At this point, the landscape around West Kennet Long Barrow had a number of construction projects going on, such as the Avebury stone circles and Silbury Hill, meaning that this long barrow predates them all. During the Romano-British period a small coin hoard was buried in the side of the long barrow, but it is thought that this was more of a symbolic offering rather than part of a burial. Over the centuries the ruin obviously attracted the interest of various antiquarians and much archaeological excavation took place in 1859 and again in 1955–56. Today it survives in a partially reconstructed state, and is a tourist attraction while at the same time still being a 'temple' for many modern Pagans, who still use it for their rituals. A beautiful monument, in a quiet and peaceful place.

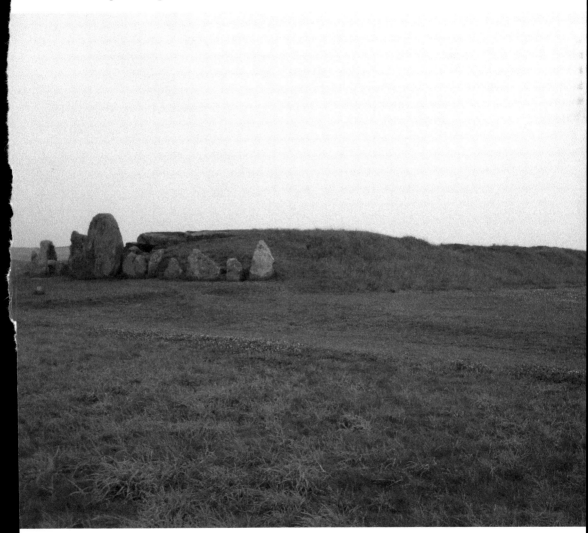

West Kennet Long Barrow. (Author's collection)

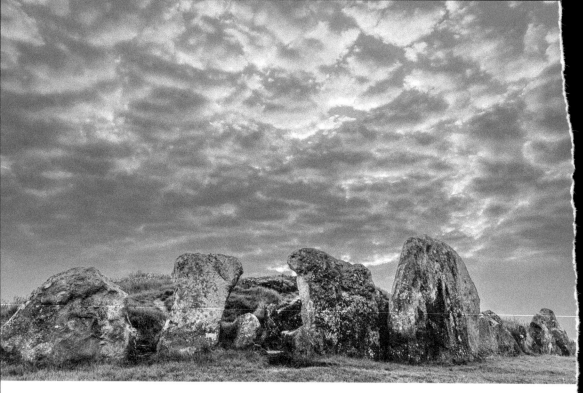

Above: Moody skies over the stone entrance. (Courtesy of Ben Cremin CC BY 2.0)

Below: An interior view of the megalithic chambered tomb. (Courtesy of Giles Watson CC BY-SA 2.0)

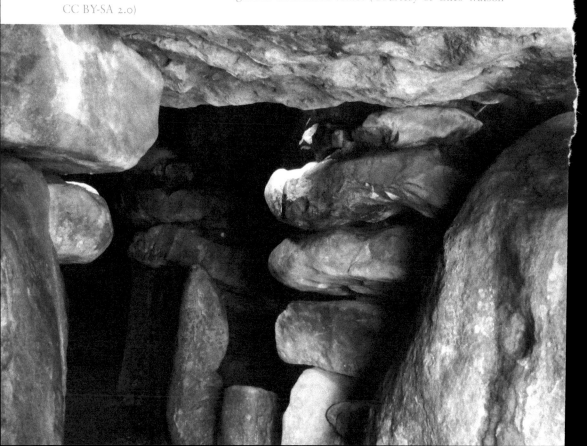

The rolling countryside of the West Wiltshire Downs. (Courtesy of Jamie Franklin CC BY 2.0)

46. West Wiltshire Downs AONB

The West Wiltshire Downs Area of Outstanding Natural Beauty is often synonymous with Cranborne Chase AONB as they do overlap, but this is such a rich landscape it deserves its own mention. Between them they cover an area of 379 square miles and is the sixth largest AONB in the country. The highest point is Win Green Down, and at 910 feet it offers stunning views of the surrounding countryside. However, with an area as large as this there are countless enjoyable walking routes and inspiring cycling paths to explore along with as much nature spotting as you want. With pretty valleys, thatched cottages, local traditions and cosy pubs, along with the option of taking up more adrenaline-fuelled adventures with all-terrain vehicles and hot-air ballooning, there is plenty to see here.

47. Wilton House

Yet another stately home within Wiltshire's borders, Wilton House near Salisbury has been the country seat of the earls of Pembroke for over 400 years. However, its history goes much further than that. It is said that a priory was founded on this site by King Egbert in around 871. Like most buildings of this nature it had significant

lands and residences and was very wealthy and powerful. That was, of course, until the Dissolution of the Monasteries by Henry VIII when Wilton Abbey was dissolved and Henry gave the estate to William Herbert, the 1st Earl of Pembroke. William was a particular favourite of the king, and he was married to Anne Parr, the sister of the future queen consort Catherine Parr, which no doubt went some way in ensuring Henry's favour. On receiving the estate he immediately began to transform the now deserted abbey into a fine house and symbol of his wealth, and that is what we see today in the form of Wilton House; however, it is not exactly how it was originally built. The Tudor house constructed in 1551 had its entire southern wing pulled down by the 4th Earl of Pembroke in 1630 and redesigned. This new southern front was built in the 'Italian' Palladian style, and it only stood for seventeen years before it was ravaged by fire, leading to further building and redesigns. While the outside of Wilton House is grand and impressive, the inside is as equally striking. There are seven quite exquisite state rooms at Wilton House

Views that stretch on for miles. (Author's collection)

Above: The Wilton estate. (Courtesy of Herry Lawford CC BY 2.0)

Below: There is so much to see across the 14,000-acre estate. (Courtesy of Herry Lawford CC BY 2.0)

and they are, according to some, equal to those in any of the great houses of Britain. These rooms were designed for only the highest-ranking members of state as house guests. At Wilton the 'Double Cube Room' takes centre stage as it runs 18 metres long with pine walls decorated with fruit painted in gold leaf, with red velvet furniture and a collection of paintings by Van Dyck hanging up. In the Great Ante Room, a Rembrandt hangs pride of place, and although the house was modernised in 1801 to create more space for pictures and sculptures it still retains its charm, and the vast array of lavishly decorated rooms in the house are worth visiting on their own. But at Wilton there are some seriously impressive gardens – first landscaped in 1632 and added to ever since – and woodlands. Seeing as the estate covers a staggering 14,000 acres, which incorporate Salisbury Racecourse and South Wilts Golf Course, this is not surprising. With a grotto, fountains and water features, there is much to see – top of that list being the Palladian Bridge over the River Nadder. Designed by the 9th Earl, it is a stunning piece of work that has inspired other such bridges, including one at Prior Park in Bath. Although the house and gardens are open to the public, William Herbert, the 18th Earl of Pembroke, and his family still live here, and it is interesting to note that Wilton has been used in numerous television shows and films.

48. Wilts & Berks Canal

The 52-mile Wilts & Berks Canal links the Kennet and Avon Canal at Semington to the River Thames at Abingdon, running through the counties of Wiltshire and Berkshire. The first plans for the canal were drawn up in 1793 and by 1795 they had received Royal Assent, allowing the Whitworth company to raise over £100,000 in shares to finance it. Work began almost immediately in 1796, with Robert Whitworth (Snr) being chief engineer until 1799, when his son William took over the reigns until the canal's completion in 1810. The year 1801 saw a new Act of Parliament passed that allowed the company to raise a further £200,000 to complete the canal, and once this was achieved a further two Acts were passed to alter toll rates on the canal, with yet another Act passed in 1815 to allow the company to raise a further £100,000 to pay off debts collected during the construction. This was four times over the initial budget, and I am sure nothing at all to do with the £255,262 William Whitworth was paid while resident engineer. Stretching 52 miles, three tunnels and a total of forty-two locks were cut to allow the canal to snake its way towards the River Thames. A reservoir was built near Swindon to supply the canal with water (at what is now Coate Water Country Park), and although the canal was a link in the chain of canals joining the West Country and the Midlands the incredible competition from the railways meant that the canal was closed and abandoned in an Act of Parliament in 1914. It fell into an awful state, with much of the canal being used for simply dumping rubbish. During the Second World War some of the locks and other canal structures were used by the army for various exercises, leaving them damaged.

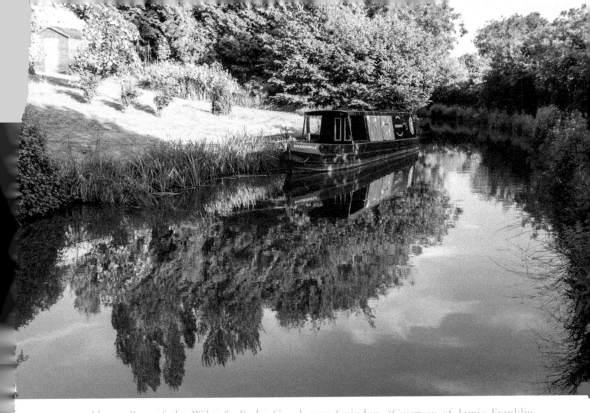

Above: Part of the Wilts & Berks Canal near Swindon. (Courtesy of Jamie Franklin CC BY 2.0)

Below: Many parts of the canal are now sadly disused. (Courtesy of Adrian Hollister CC BY 2.0)

And so the canal remained unloved, until 1977, when the first group was set up to protect what remained of the canal, paving the way for the formation of the Wilts & Berks Canal Trust in 1997, who have since rewatered many of the rural sections while also rebuilding a number of canals and bridges. Although there is still a lot of restoring to do, there are many parts of the Wilts & Berks Canal that are easily accessible by the public today.

49. Win Green

The smallest entry in my '50 Gems', Win Green Down is a specific 26-hectare part of Cranborne Chase. It is listed as a Site of Special Scientific Interest, and at its summit, Win Green, a clump of trees sit at 277 metres above sea level. Defined as a Marilyn – a peak with a prominence above 150 metres – from here on a clear day it is possible to see the Isle of Wight, Salisbury, Glastonbury Tor and the Quantocks.

A view of Win Green. (Courtesy of Marilyn Peddle CC BY 2.0)

50. RAF Yatesbury

In 1916, farmland to the south of the village of Yatesbury was turned into an aerodrome for the newly formed Royal Flying Corps. Actually, consisting of two airfields, an East and a West Camp, both with buildings and hangars, target areas were set out as pilot training began with No. 99 Squadron until the station was prematurely closed in 1920 in the aftermath of the First World War. In 1936, the Bristol Aeroplane Company opened part of the site as a civilian flight school, with trainees prepared for service in the RAF as the threat of the Second World War loomed large. It is interesting to note that legendary pilot Guy Gibson, leader of the famous 'Dambusters' raid in 1943, took his initial training here at the end of 1936. At the outbreak of the war the site was taken over by the Air Ministry to train airborne wireless operators, and from 1942 radar operators. No. 2 Radio School, as East Camp became known, had a certain Arthur C. Clarke (later to be a science fiction author and inventor) as one of its instructors. Although Yatesbury was primarily used for training purposes it is estimated that around seventy died from here, with a number buried in the village's churchyard. The Cold War saw the continued training of radar operators, along with mechanics and fitters and from

One of the many derelict buildings at the site of RAF Yatesbury. (Courtesy of Ben Cremin CC BY 2.0)

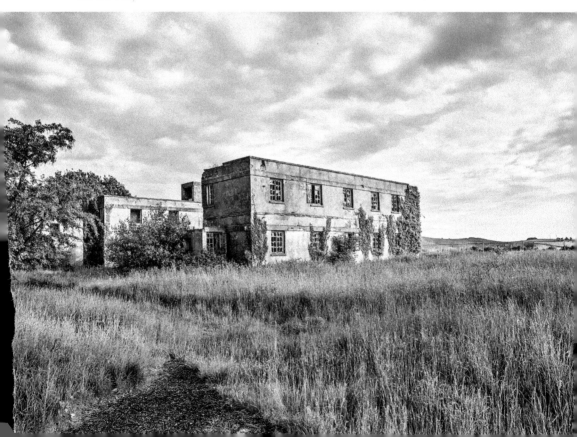

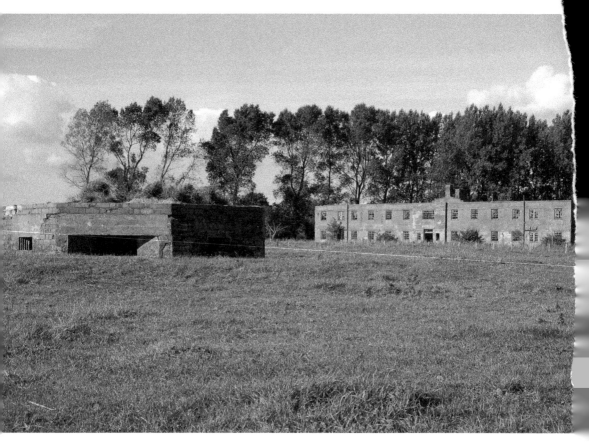

Some of these structures are now listed buildings. (Courtesy of Ben Mitchell CC BY 2.0)

1954 to 1958 the site became RAF Cherhill, 27 Group Headquarters, Technical Training Command. The airfield closed in 1965 and in 1969 the vast majority of the land returned once again to farming, with the wooden huts being demolished. Only a handful of brick structures remained and the two groups of hangars, built in 1916, and the former officers' mess and offices, built in 1936, were designated as Grade II listed buildings. Sadly, one hangar was demolished in 2012 because of its poor condition, while the other two remain standing and on the Heritage At Risk Register. These remaining buildings are a reminder of the courage and bravery shown by millions, that ensured our freedom today.

Acknowledgements

Researching the history of a place you have lived near for the last few years is an exhilarating and time-consuming process that has allowed me to discover so many new sights, sounds, stories and places. In this day and age it is possible to do a lot of research online, but nothing compares to actually heading out and exploring things for yourself. Only then, when you see the history in its original environment, does it start to make sense. Investigating the different aspects of this book has led me to find out some incredible things and meet a number of wonderful people, all of whom have been willing to share their knowledge and expertise, and this is so important in passing on the history of our communities to the next generation.

However, this book has not been without its challenges. Condensing all that is great and good about Wiltshire into just fifty key gems is difficult, and inevitably I have not been able to write about every single location.

I need to express my gratitude to the organisations, people and photographers who have kindly shared their knowledge and allowed me to use their photographic work in my book, as their photographs help to tell the story of these wonderful locations.

I would also like to thank Nick Grant, Nikki Embery, Jenny Bennett, Becky Cadenhead and all at Amberley Publishing for their help in making this project become a reality, as well as my wife Laura and young sons James and Ryan, who accompanied me on many wonderful day trips across the length and breadth of Wiltshire, a county with beautiful scenery and a rich, vast heritage.

About the Author

Andrew Powell-Thomas writes military history, local heritage and children's fiction books. He regularly speaks at events, libraries, schools and literary festivals across the South West and lives in Somerset with his wife and two young sons. Always researching and writing, he has more books and events planned, and it is possible to keep up with everything he is up to by following him on social media or by visiting his website at www.andrewpowell-thomas.co.uk.

Andrew's other titles available from Amberley Publishing:

The West Country's Last Line of Defence: Taunton Stop Line
Somerset's Military Heritage
50 Gems of Somerset
Historic England: Somerset
Devon's Military Heritage
Cornwall's Military Heritage
Wiltshire's Military Heritage
Castles and Fortifications of the West Country
50 Gems of Jersey
The Channel Islands Military Heritage